peaceful places
Los Angeles

Other titles of interest

Peaceful Places: New York City

Peaceful Places: San Francisco

peaceful places
Los Angeles

110 Tranquil Sites in
the City of Angels and
Neighboring Communities

by Laura Randall

MENASHA RIDGE PRESS
www.menasharidge.com

Copyright © 2010 by Laura Randall
All rights reserved
Published by Menasha Ridge Press
Printed in the United States of America
Distributed by Publishers Group West
First edition, first printing

Cover design by Scott McGrew
Text design by Annie Long
Cartography by Steve Jones
Cover photograph by Laura Randall: Point Vicente Interpretive Center bluffs trail in
 Rancho Palos Verdes, page 152.
All photographs by Laura Randall
Back cover photographs by Laura Randall

Library of Congress Cataloging-in-Publication Data

Randall, Laura, 1967-
 Peaceful places, Los Angeles : 110 tranquil sites in the City of Angels and
 neighboring communities / Laura Randall. -- 1st ed.
 p. cm.
 ISBN-13: 978-0-89732-719-0
 ISBN-10: 0-89732-719-5
 1. Los Angeles (Calif.)--Guidebooks. 2. Los Angeles Region (Calif.)--Guidebooks.
 3. Quietude. I. Title. II. Title: One hundred ten tranquil sites in the City of
 Angels and neighboring communities.
 F869.L83R36 2010
 979.4'94--dc22
 2010017752

Menasha Ridge Press
P.O. Box 43673
Birmingham, Alabama 35243
www.menasharidge.com

contents

peaceful places alphanumerically

dedication

To John, Jack, and Theo

acknowledgments

M y sincere thanks go to the people with the foresight and talent to create or maintain all of the special places mentioned in this book:

The spirit of the late Amir Diamaleh lives on in Amir's Garden, the green paradise he carved out of a Griffith Park hillside (page 1).

Wallis Annenberg's philanthropy drove the opening of two public venues that the city sorely needed in 2009 (pages 3 and 5).

Every Saturday, Tai Chi master Chao-Li Chi transforms the Pacific Asia Museum's courtyard into a haven of camaraderie and serenity (page 140).

The volunteers at the Audubon Center at Debs Park help make it one of the city's best and most accessible parks (page 53).

Donna Harris, Davida Taurek, Ann Flower, and a cast of docents provided generous help and guidance with my research.

And here's to all of the gardeners, servers, and park rangers who show ongoing appreciation and respect for the tranquility of their workplaces, as much as those of us who visit them do.

Special thanks must also go to my friend and neighbor Haru Kuromiya, whose wise suggestions and infectious enthusiasm for Southern California motivated me throughout the research and writing of this book. At 83, she is a true inspiration for anyone who loves discovering new places, and I am so grateful for her company and boundless energy. I am also grateful to Molly Merkle at Menasha Ridge Press for suggesting that I write this book and to my editor, Susan Haynes, for her invaluable guidance and encouragement.

Finally, I want to thank my husband, John, and my children, Jack and Theo, for keeping me company on many of my expeditions, and for understanding when I needed my own time for quiet reflection.

Laura Randall
Los Angeles
May 2010

*T*ranquil isn't the first word that comes to mind when most of us think of life in Los Angeles, especially these days. Yet when I started my research for this book, it was incredibly easy to tick off places all over the city that qualify as peaceful escapes. I started with the obvious ones: gardens, parks, beaches, and spiritual centers from Malibu to San Gabriel. I followed those with quirkier, unexpected sanctuaries: a Japanese pastry shop in Lomita, a bookshop on the Venice boardwalk, an art gallery in Altadena, and trails in La Cañada Flintridge and Agoura Hills. Soon I had a list so long that I had the luxury of excluding places that didn't fully live up to my expectations of what a peaceful place should be.

The result: As different as they are from one another, every site featured in this book should leave you feeling refreshed, calm, and perhaps a bit more balanced and ready to face the freeway traffic, bright lights, and other stimuli and daily pressures that characterize life in Los Angeles. At the same time, many of these peaceful places are as unique and fascinating as the City of Angels itself. From the Moroccan-themed rooftop speakeasy in Hollywood to the working ranch deep in the San Fernando Valley, I hope they appeal to and surprise longtime Angelenos as much as first-time visitors who have stars in their eyes.

From another perspective, as much as I know and love Los Angeles, nothing prepared me for the turbulent year that marked much of my research window for this book. Sweeping city and state budget cuts, combined with a record number of housing foreclosures and job losses, were a reality for many of us Southern Californians. Even things we normally take for granted, such as free beach access and world-class museums, were drastically affected by the economic downturn. Parking fees at state beaches rose to

record highs, many nature centers scaled back their hours to save on staff and mainte-
nance costs, and several beautiful state parks faced the threat of permanent closure.

On a personal level, I found myself in strong need of some solace in the late summer
of 2009 when the Station fire—the largest wildfire in the history of Los Angeles County—
forced my family and hundreds of other San Gabriel Valley residents to evacuate for
several days. One Sunday afternoon, my husband, two small sons, and I escaped the
smoke and real threat of losing our home. We ventured to the beaches of northern
Malibu, where we swam, watched pods of dolphins cavort, and felt as if we were a mil-
lion miles away from the firestorm raging just over the mountain range. It was a classic
L.A. moment: Chaos and ugliness dominated one corner of town while absolute tran-
quility could be found just around the bend. For every strip mall and smog-check garage
this city has, there is an unexpected hillside garden or spectacular scenic overlook to
counter it and make you want to live nowhere else on earth.

Now more than ever we all need places to escape to for a day or even just a lunch
hour. Thus, in this book I offer easy getaways such as the bluffs trail at Point Vicente
Interpretive Center in Palos Verdes (page 152), where you can lose yourself in sweep-
ing ocean views, or Pasadena's Zona Rosa Caffe (page 210), where no one minds if you
nurse an espresso and read a novel for an entire afternoon.

Peaceful Places: Los Angeles not only names many unexpected spots that even longtime
residents don't know about, but it also includes tips on the quietest times or seasons to
visit well-known destinations such as the Getty Center (page 72) and Avalon (page 11) on
Santa Catalina Island. I hope that it will encourage you to discover new places and revisit
old standbys. Most of all, I want it to help you unplug, unwind, and embrace the City of
Angels and all its glorious, quirky beauty.

Laura Randall
Los Angeles
May 2010

P.S. A note about getting around Los Angeles: I include, wherever possible, information on reaching a destination by public transit. In cases where there is no easy bus route or subway stop—or where multiple transfers get so complicated that it undermines the overall peaceful experience—you will see "N/A" (not applicable) instead of a specific bus or metro listing. However, the Metropolitan Transportation Authority's bus and rail system, which extends across all of Los Angeles County, can get you to most of the sites in this collection. Most Metro bus lines link with all Metro rail lines—Gold, Red, Blue, Green, and Purple—as do other smaller bus lines from Pasadena to the South Bay. The Big Blue Bus (bigbluebus.com) serves Santa Monica, Venice, and other areas of west Los Angeles, while Culver CityBus (culvercity.org) spans the communities of Marina del Rey, Culver City, and Westwood. DASH, an acronym for Downtown Area Short Hop, is an easy and inexpensive way to get around downtown L.A. and Hollywood (ladottransit.com/dash). The Orange County Transportation Authority (octa.net) serves the Laguna and Newport Beach areas. The Pasadena ARTS (Area Rapid Transit System) buses connect with several Gold Line metro stops in Pasadena and traverse all the city's major thoroughfares (cityofpasadena.net/artsbus). Glendale Beeline (glendale beeline.com) buses serve the city of Glendale. For more details on L.A.'s plentiful and diverse public transportation choices—a surprise for many people—visit experiencela. com/GettingAround.

Amir's Garden (see page 1)

three paths to 110 peaceful places

*I*n *Peaceful Places: Los Angeles,* author Laura Randall serves up 110 locales where you can enjoy a few hours of quiet time in the greater metro area and farther afield. To make it easy for you to find an entry that suits your mood and desired neighborhood or type of place, we have organized the sites in three different ways:

the path BY CATEGORY

The Peaceful Places by Category guide (page xix) showcases the sites as listed below. The full text for each destination also includes its category at the top of that individual entry. In many cases it was difficult to categorize a place, as it might be a historic site in an outdoor habitat with a scenic vista that feels like a spiritual enclave that is an urban surprise where you can take an enchanting walk! But we tagged each of the sites as seemed most fitting for the focus of the author's description.

Day Trips & Overnights	Outdoor Habitats	Scenic Vistas
Enchanting Walks	Parks & Gardens	Shops & Services
Historic Sites	Quiet Tables	Spiritual Enclaves
Museums & Galleries	Reading Rooms	Urban Surprises

the path BY AREA

The Peaceful Places by Area guide (page xxiii) and maps (pages xxvii) locate sites according to these nine geographic divisions:

Downtown (Map 1)	Santa Monica & Venice (Map 4)	San Fernando Valley (Map 7)
Hollywood & Environs (Map 2)	South Bay & Long Beach (Map 5)	San Gabriel Valley (Map 8)
West Los Angeles (Map 3)	Malibu & Environs (Map 6)	Farther Afield (Map 9)

the path **ALPHANUMERICALLY**

Beginning on page 1, each entry unfolds in the main text in alphabetical order and is numbered in sequence. The number travels with that entry throughout the book in the table of contents (page v), in the Peaceful Places by Category guide (page xix), in the Peaceful Places by Area guide (page xxiii), and on the maps (page xxvii).

PEACEFULNESS RATINGS

Preceding the main text for each profile, boxed information notes the entry's category and area. This capsule information also includes the author's rating for the site, on a scale of one to three stars, as follows:

✪ ✪ ✪ Heavenly anytime

✪ ✪ Almost always sublime

✪ Tranquil if visited as described in the entry—during times of day, week, season, and so on— and possibly avoided at certain times

—The Publisher

peaceful places by category

QUIET TABLES

READING ROOMS

SCENIC VISTAS

peaceful places by area

DOWNTOWN (Map 1)

HOLLYWOOD & ENVIRONS (Map 2)

Note: No map location is shown for Peaceful Place 103: Watsu® massage (page 196). Contact information is provided in the listing.

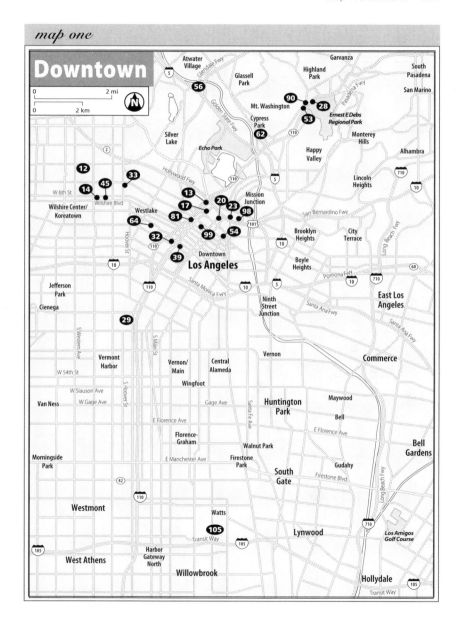

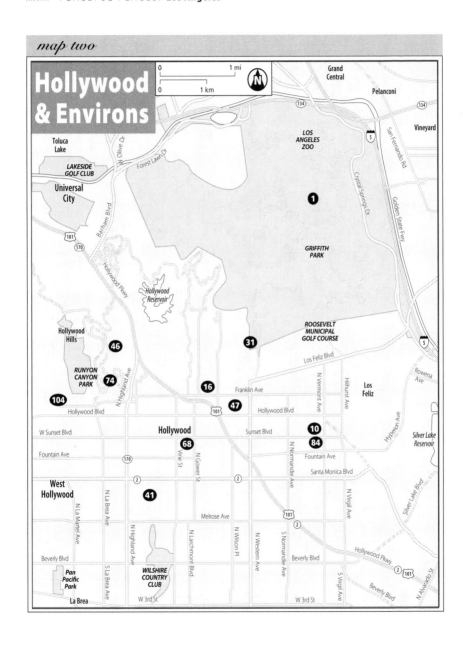

map two

Hollywood & Environs

0 ——————————— 1 mi

0 ——————————— 1 km

Toluca Lake

LAKESIDE GOLF CLUB

Universal City

Hollywood Hills

RUNYON CANYON PARK

Hollywood

West Hollywood

Pan Pacific Park

WILSHIRE COUNTRY CLUB

La Brea

Grand Central

Pelanconi

Vineyard

LOS ANGELES ZOO

GRIFFITH PARK

ROOSEVELT MUNICIPAL GOLF COURSE

Los Feliz

Silver Lake Reservoir

Rowena Ave

Hollywood Reservoir

Forest Lawn Dr

N Olive Dr

Barham Blvd

Hollywood Pkwy

San Fernando Rd

Crystal Springs Dr

Golden State Fwy

Los Feliz Blvd

Franklin Ave

Hollywood Blvd

W Sunset Blvd

Sunset Blvd

Hollywood Blvd

Fountain Ave

Fountain Ave

Santa Monica Blvd

Melrose Ave

Beverly Blvd

Beverly Blvd

Hollywood Pkwy

Beverly Blvd

W 3rd St

W 3rd St

N Highland Ave

N Gower St

Vine St

N La Brea Ave

N La Cienega Ave

N Martel Ave

S La Brea Ave

N Highland Ave

N Larchmont Blvd

N Wilson Pl

N Western Ave

S Normandie Ave

N Normandie Ave

N Vermont Ave

Hillhurst Ave

Hyperion Ave

Silver Lake Blvd

N Virgil Ave

S Virgil Ave

N Alvarado St

101

170

134

134

5

5

101

101

170

2

2

2

2

1

31

46

74

104

16

47

68

41

10

84

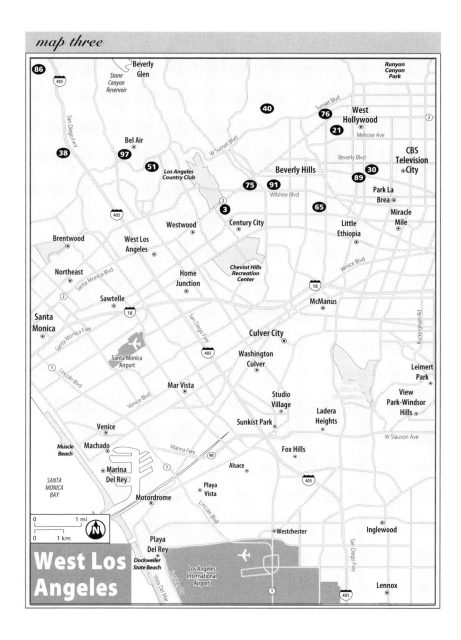

map three

West Los Angeles

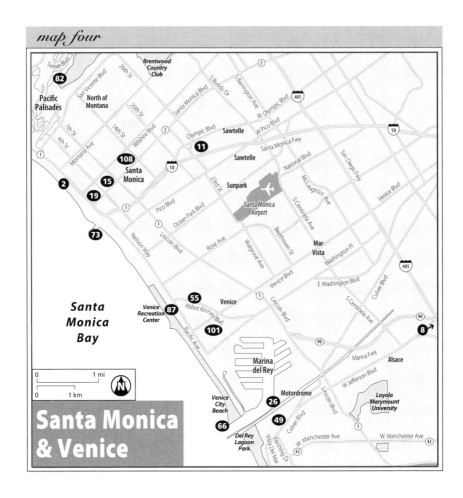

map four

Santa Monica & Venice

Santa Monica Bay

Pacific Palisades

North of Montana

Santa Monica

Sawtelle

Sawtelle

Sunpark

Santa Monica Airport

Mar Vista

Venice

Marina del Rey

Motordrome

Alsace

Loyola Marymount University

Venice Recreation Center

Venice City Beach

Del Rey Lagoon Park

Brentwood Country Club

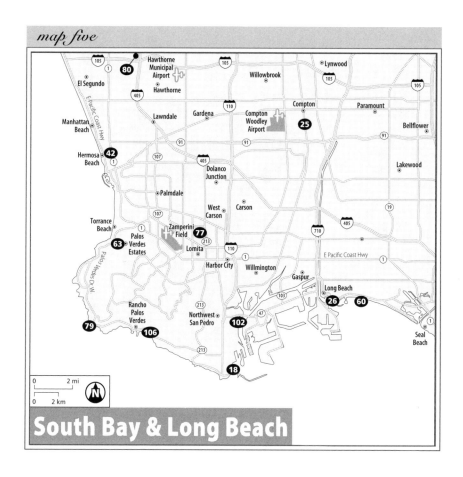

map five

South Bay & Long Beach

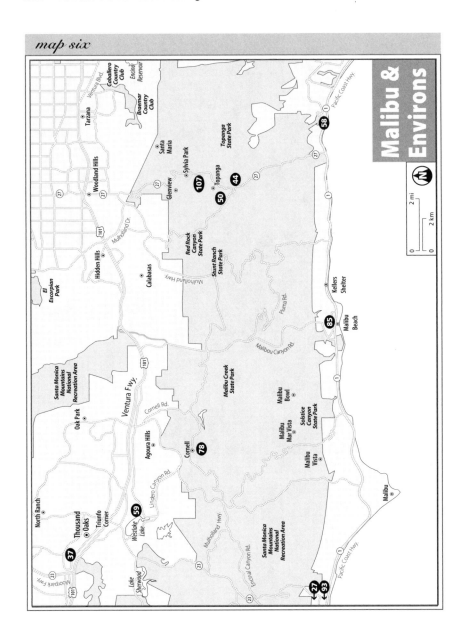

map seven

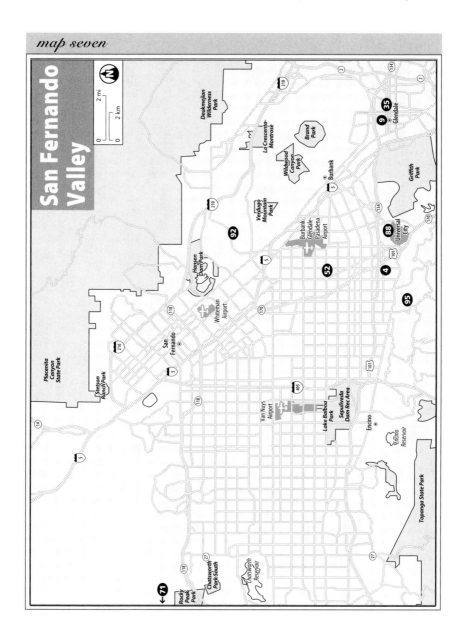

San Fernando Valley

2 mi

2 km

Deukmejian Wilderness Park

La Crescenta-Montrose

Brand Park

Wildwood Canyon Park

Burbank

Verdugo Mountain Park

Burbank-Glendale-Pasadena Airport

Griffith Park

Glendale

Universal City

Hansen Dam Park

Whiteman Airport

San Fernando

Placenita Canyon State Park

Stetson Ranch Park

Van Nuys Airport

Lake Balboa Park

Sepulveda Dam Rec Area

Encino

Encino Reservoir

Topanga State Park

Chatsworth Reservoir

Chatsworth Park-South

Rocky Peak Park

map eight

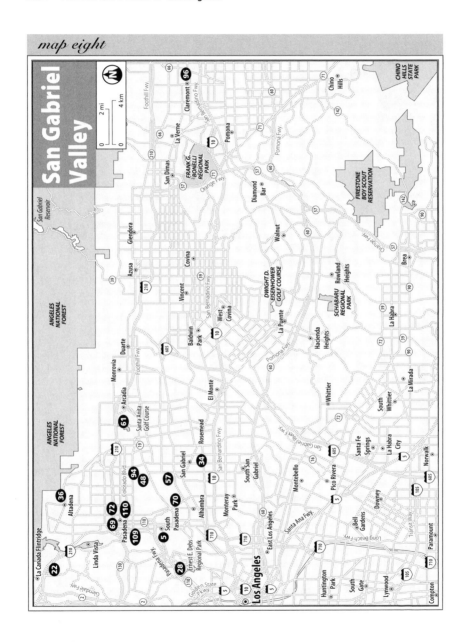

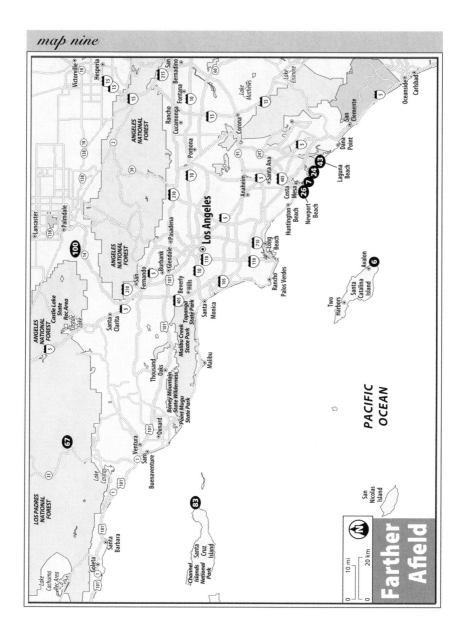

Crystal Cove State Park (see page 45)

peaceful place 1

AMIR'S GARDEN
Griffith Park, Hollywood (MAP 2)

CATEGORY ↝ enchanting walks ✪ ✪ ✪

*I*t's a steep half-mile hike up a dusty, shadeless path to reach Amir's Garden, but once you step into its cool oasis of jacarandas, pine trees, jade, and oleander, you will forget all about the effort. Amir Dialameh, an immigrant from Iran and avid outdoorsman, planted the garden in 1971, envisioning it as a resting spot for hikers exploring Griffith Park. The site was ravaged by fire and occasional vandalism over the years, but a loyal cadre of volunteers has maintained it since Dialameh's death in 2003.

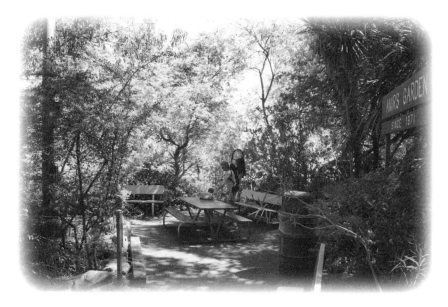

A secluded picnic area at Amir's Garden

Here you will find benches and picnic tables. Natural steps carved into a terraced hillside overlook the southern and western reaches of Griffith Park. It's a lovely place for a picnic with children, as well as the perfect resting spot for horseback riders and hikers trekking the nearby fire roads. (I like the secluded table at the end of the steps to the left of the large Amir's Garden sign.) "There are so many pressures, so many problems," Dialameh once said when asked why he created this hilltop Eden. "All people do is complain. They need to get away from that." Nearly 40 years later, you couldn't ask for a better escape than Amir's Garden. To get there, park at Mineral Wells Picnic Area and look for the unmarked trail that leads uphill past a large green water tank.

⌣ essentials

▤ Griffith Park Visitors Center, 4730 Crystal Springs Drive, Los Angeles, CA 90027

📞 (323) 913-4688 🌐 amirsgarden.org $ Free

🕐 Daily, sunrise–sunset 🚌 Metro Bus Local Line 96

peaceful place 2

ANNENBERG COMMUNITY BEACH HOUSE
Santa Monica (MAP 4)

CATEGORY ✧ scenic vistas ✪

When the Annenberg Community Beach House opened in 2009, its mission was admirably clear: to turn the former site of an exclusive beach club and celebrity hangout into a gathering place accessible to everyone. From day one it was a big success, drawing families and history buffs to splash in the original 1930s-era pool and tour the restored Marion Davies Guest House. (The main mansion, where film actress Davies and newspaper tycoon William Randolph Hearst lived and partied, was demolished in the 1950s.)

Pool reservations ($10 adult; $4 child) sell out regularly in the summer. But you'll want to catch the Beach House at its quiet, most enjoyable best. The raucous kid quotient disappears come September, especially on weekdays. And while the pool is closed from September through April (except for occasional weekends), the second-floor view deck remains open daily. Overlooking

Second-floor deck at Annenberg Community Beach House

the pool area and a pretty stretch of Santa Monica State Beach, the deck has several tables, free Wi-Fi access, and a stay-as-long-as-you-like vibe. Settle in with a laptop or reading material, and imagine what it must have been like to own that view. A bonus: The eco-friendly washrooms just may be the cleanest, prettiest public restrooms in town.

⌣ essentials

☰ 415 Pacific Coast Highway, Santa Monica, CA 90402

📞 (310) 458-4904 🌐 beachhouse.smgov.net

$ $8–$10 parking; pool access $10 for adults, $4 for age 17 and under

🕐 View deck: Daily, 8:30 a.m.–5:30 p.m.; check Web site for pool schedule

🚌 Big Blue Bus Lines 1, 7, or 8

Views of the pool deck and Santa Monica Beach

peaceful place 3

ANNENBERG SPACE FOR PHOTOGRAPHY
Century City, West Los Angeles (MAP 3)
CATEGORY ⌣ museums & galleries ✪ ✪

*A*fter you have lived in L.A. long enough, you learn to avoid certain places unless absolutely necessary. The 405 freeway is one; Century City, with its skyscrapers and anti-pedestrian layout, is another. But the opening of the city's first photography museum, in 2009, has single-handedly made Century City worth a visit. Located on the site of the historic Shubert Theatre, it is as sleek and modern as the new (2007) headquarters of Creative Artists Agency (right next door), where top talents make

A rock garden fronts L.A.'s only photography museum.

high-end deals. Inside the Annenberg, the circle-within-a-square design mimics a camera, which is perfect for hosting rotating exhibits of photographs. Varied themes have included sports photography and scenes of Los Angeles.

While stark, it's still a fantastically inviting space: The floors are fashioned out of recycled tires, and a digital gallery with multiple screens displays a rotating cast of photos. Even the bathroom, with its water show and futuristic design, is a must-see. Perhaps the most welcoming spot of all is the kitchen—a sort of meeting place for photographers. You're welcome there, too, and you'll find citrus water, a guest comment book, and a reading room stocked with magazines and books about art and photography. Stay as long as you like, and silently thank publishing heiress Wallis Annenberg for bringing art and the community together in a very unlikely part of town.

ᴗ᭄ essentials

🖃	2000 Avenue of the Stars, Los Angeles, CA 90067
ℭ	(213) 403-3000
⌖	annenbergspaceforphotography.org
$	Free; $3.50 parking
🕐	Wednesday–Sunday, 11 a.m.–6 p.m.
🚌	Metro Bus Rapid Lines 704 or 728

peaceful place 4

AROMA CAFE

Studio City, San Fernando Valley (MAP 7)

CATEGORY ⌣: quiet tables ✪ ✪

o not be put off by the long line that sometimes forms outside the door of Studio City's coolest independent coffeehouse. If you don't mind waiting a few minutes (sometimes longer on weekends) to place your order, you will find plenty of pleasant seating options behind those doors. One day, you may be in the mood for the leafy backyard setting anchored by a Zen fountain. Another time, the chandeliered dining nook could strike your fancy, with its door that leads to a fantastic little bookshop, Portrait of a Bookstore. The meal or drink order that you place at the counter will be delivered to your table, usually within a very short time by a very nice server.

Located on a picturesque block of yoga studios, cafes, and boutiques, this San Fernando Valley bungalow started as a coffee counter and has gradually expanded into a breakfast, lunch, and dinner scene with an eclectic mix of offerings, from Kobe burgers and huevos rancheros to wild rice and tofu salad. Despite its popularity, it has somehow managed to stay down-to-earth and keep appealing to a variety of customers. As if to signal that dog owners are welcome, water bowls dot the outside areas; parents relax here with young kids; and celebrities pop in from the nearby big entertainment studios.

While the food is above average, it's the setting that keeps everyone coming back. The tables, especially those lining the alley, are spaced far enough apart that nearby conversations don't intrude on your private sphere. Staff never pressure you to leave, and it's tempting to use the place as a sort of home away from home at any time of day. Bring your laptop, order a cup of micro-roasted coffee or cinnamon-fig tea, and work on that screenplay until you've got a passable draft. Or buy a Joan Didion novel in the adjacent book and gift shop and read the afternoon away.

essentials

☰ 4360 Tujunga Avenue, Studio City, CA 91604

✆ (818) 508-0677

🌐 aromacoffeeandtea.com

$ Per menu selections

🕐 Monday–Saturday, 6 a.m.–11 p.m.; Sunday, 7 a.m.–11 p.m.

🚌 N/A

peaceful place 5

ARROYO VISTA INN

South Pasadena, San Gabriel Valley (MAP 8)

CATEGORY ⌒ day trips & overnights ✪ ✪

I predict that you will like many things about this restored Craftsman inn: its views of the San Gabriel Mountains, the central location between the Rose Bowl and downtown, its comfortable elegance. Located at the top of a steep, winding drive-

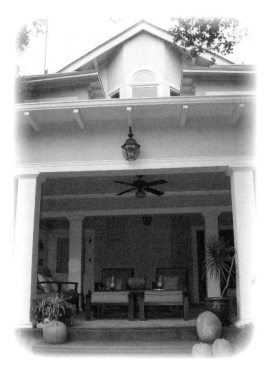

The inn's welcoming front porch

way edged by a wall of rocks from the nearby Arroyo Seco, it was restored to its 1910 glory by attorney Pat Wright, who lives next door. The 10 rooms are decorated in soothing hues of blue and beige, some with distinct touches such as claw-foot bathtubs, original stained glass windows, and luxury four-poster beds. The Daybreak Terrace Room is a favorite, with a sunny east-facing balcony and two-person tub with hillside views. I also fell in love with the sloped ceilings and cozy serenity of the Tree House Room.

Other modern-meets-homey touches include Wi-Fi access (but no televisions), a front veranda

that cries out for mint juleps and a couple of idle hours, homemade toffee, and a wine and cheese hour in the late afternoon. Breakfast is served in a formal dining room and might feature asparagus strata or oatmeal-cookie pancakes with bacon, baked apples, and orange juice squeezed from the fruit of trees outside. L.A. could use more understated, hands-on inns like this one to balance out the city's plethora of glitzy, high-end hotels.

essentials

✉	335 Monterey Road, South Pasadena, CA 91030
☎	(323) 478-7300
🌐	arroyovistainn.com
$	Rooms start at $175
🕐	Open year-round
🚋	Metro Rail Gold Line to Mission Street/South Pasadena

peaceful place 6

AVALON

Santa Catalina Island (FARTHER AFIELD: MAP 9)

CATEGORY ⌣: day trips & overnights ✪ ✪

I know. Despite its small-town charms, Catalina Island in the summer can be as busy as any beach town on the Southern California coast. Boats from the mainland require reservations weeks in advance, and hotel and tour-package rates can be painfully high. But then there's the off-season, October through March. That is a whole different, quieter story. An hour's ferry ride deposits you where you can listen to waves lapping against anchored boats, book a comfortable hotel room for less than $100, and walk the entire arched pathway from the ferry dock to the Catalina Casino without passing more than a handful of people—and most of them island residents, no doubt. The downside:

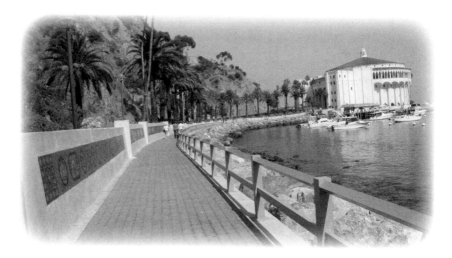

Off-season visitors have Avalon's casino walkway to themselves.

Many businesses close for the season, and trolley and bus service are limited to weekends. But if you keep your expectations low-key and do a little advance planning, you'll find that it's a very easy, pleasant way to escape from Los Angeles for a day or two.

Avalon itself is perfect for wandering and collecting your thoughts, especially if you leave the main tourist drag. Hike up to Zane Grey's former home (now the Zane Grey Pueblo Hotel). Stroll pretty, closed-to-cars Eucalyptus Avenue. And discover on your own the many staircased alleys that yield amazing views of the harbor. In the cooler weather of the off-season, the 40-minute uphill trek to the Wrigley Memorial & Botanical Gardens offers an exhilarating experience. At the garden, you can check out the harbor views and the open-air monument that honors the chewing-gum magnate who once owned most of the island. Those looking for fine dining will want to rent a golf cart and drive up to the hilltop Inn on Mount Ada (the former Wrigley mansion), which takes a limited number of lunch and dinner reservations from non-hotel guests. Catch the last ferry home (or not), and revel in the fact that this unique paradise is only 22 miles from a major metropolis.

essentials

⌨ One of the eight islands in the Channel Islands archipelago, Santa Catalina lies south by southwest of Los Angeles; zip code 90704. Ferry terminals are located at 95 Berth, San Pedro, CA 90731; 320 Golden Shore, Long Beach, CA; and 34675 Golden Lantern Street, Dana Point, CA 92629

☎ (310) 510-1520 🌐 catalina.com; catalinaexpress.com (for ferry information)

$ Round-trip ferry from Long Beach or San Pedro: $66.50 for adults, $51 for children ages 2–11; Zane Grey Pueblo Hotel, off-season rates (mid-October through May): $80–$110; Inn on Mount Ada, off-season rates (November through April): start at $375

🕐 The island is accessible year-round by *Catalina Express* ferry, by private boat, and by small planes

🚌 *Catalina Express* boats leave daily from Long Beach, San Pedro, and Dana Point

peaceful place 7

BALBOA ISLAND FERRY

Newport Beach (FARTHER AFIELD: MAP 9)

CATEGORY ⌣ scenic vistas ✪ ✪

*H*ere's what I would do if I had a free afternoon, a few dollars in my pocket, and an out-of-town guest who couldn't get past L.A.'s glut of freeways and strip malls. I would drive to Balboa Island in Newport Beach, park on the street, and hop on the century-old ferry to the Balboa Peninsula. The gentle five-minute ride past bobbing seals, pelicans, and boats drifting in and out of the channel is all it takes to make a convert out of anyone who seems impervious to Southern California's charms.

The ferry, which operates almost around the clock in the summer, drops you off near the Coney Island–like area known as the Balboa Fun Zone. Walk just three blocks

The Balboa Island Ferry takes its sweet time crossing the channel.

beyond those boisterous amusements to the soothing beach and pier. Time your ferry return for sunset, when everything in the channel seems to slow down and inspire you to take deep breaths. If you're feeling fine and want to extend the visit into the evening, turn right at the ferry dock after disembarking and follow the waterfront walkway a half mile or so to the commercial stretch of Marine Avenue. On one side, you'll pass docked boats swaying gently; on the other, you might see residents relaxing on their decks or docks, wineglasses in hand. Peacefulness tip: On summer weekends, the passenger ferry typically carries bicycles and three cars at a time, but during weekday afternoons or anytime off-season (September through April), your chances are excellent for walking right on—no wait.

✍ essentials

410 South Bayfront Street, Newport Beach, CA 92662

(949) 673-1070 balboaislandferry.com

$1 per ride for adults; $0.50 for ages 5–11

Summer hours: Sunday–Thursday, 6:30 a.m.–midnight; Friday–Saturday, 6:30 a.m.–2 a.m.

Orange County Transit Authority Bus Route 71

peaceful place 8

BALDWIN HILLS SCENIC OVERLOOK
Culver City (MAP 4)

CATEGORY ⌣ scenic vistas ✪ ✪ ✪

hether you reach this hilltop park by climbing the cardio-busting trail off Jefferson Boulevard or by driving up and paying to park in the lot, you will be happy that you made the effort. Opened in spring 2009, it is one of the state's newest parks. In a high-traffic industrial area sorely in need of open space, this setting does a good job of almost erasing memories of the area as a longtime oil-drilling hub. Scrub sage and other native plants surround a sleek steel-and-glass visitor center, and a loop trail at the top leads to a clearing with a jaw-dropping panorama: skyscrapers downtown and in Century City, the peaks of the San Gabriel Mountains, Santa Monica Bay, and the outline of Santa Catalina Island. You can hear the sounds of nature—wind whistling through the causeways of the three-building visitor complex—while you relax at picnic tables (usually empty and waiting for you).

From this location you'll have perhaps the best, and most realistic, vistas of Los Angeles County (take it all in, from strip malls and tract homes to the wide-open Pacific Ocean). Even on heavy smog days, the views are good, but the views are most stunning a day or two after a good rain. Then the scene unfolds in a postcard-perfect display: downtown L.A. backed by the San Gabriel Mountains and a dramatic, snowcapped Mount Baldy.

⌣ essentials

🖳	6300 Hetzler Road, Culver City, CA 90232	📞	N/A
🌐	parks.ca.gov (Type in "Baldwin Hills")	💲	$6 parking
🕐	Daily, 8 a.m.–6 p.m.; Visitor center: Thursday–Sunday, 10 a.m.–6 p.m.		
🚌	Culver CityBus Line 4		

peaceful place 9

BARNES & NOBLE CAFE BALCONY
Americana at Brand, Glendale, San Fernando Valley (MAP 7)
CATEGORY ⌣ quiet tables ✪ ✪

*Y*ou could say that this mall, the Americana at Brand, is Glendale's version of Disneyland—clean, easy to navigate, and pristinely landscaped to give that giddy feeling that you've left the real world far behind. Upscale boutiques (such as Juicy Couture and Kitson) vie for attention with a variety of restaurants (from the chichi Katsuya to Cheesecake Factory). Dancing fountains and a roving trolley keep the kids happy. Love it or loathe it, it is a true Southern California experience—and one that

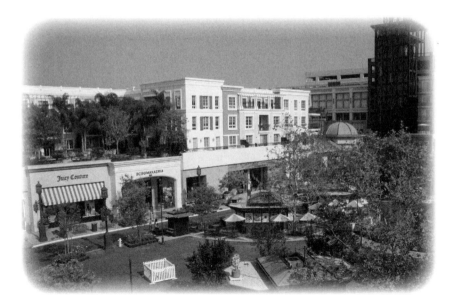

View from the Barnes & Noble balcony at Americana at Brand

you may want to escape from after handling your shopping business. Head for the best vantage point, the third-floor balcony at Barnes & Noble. Buy a coffee drink or scone (or not) at the inside Starbucks cafe, and grab a table overlooking the Green and all its faux prettiness. The noise is muted, and the views are as lofty as those from the luxury condominium units next door.

The balcony holds about a dozen tables and draws a mix of people, from laptop users to moms with small children, though its out-of-view location seems to attract more individuals than groups. For the lowest noise levels, avoid going on Tuesday mornings, when the mall hosts a popular kids' music concert.

⌣ essentials

☰ The Americana at Brand, 210 Americana Way, Glendale, CA 91210

☎ (818) 545-9146

🌐 americanaatbrand.com

$ Free except for coffee and snack purchases

🕐 Daily, 9 a.m.–11 p.m.

🚌 Glendale Beeline Bus Routes 1, 2, 3, or 4

peaceful place 10

BARNSDALL PARK

Los Feliz, Hollywood (MAP 2)

CATEGORY ↷ parks & gardens ✪ ✪

A lot goes on at this hilltop park during the summer: outdoor Shakespeare, wine tastings, art workshops, and regular tours of the cement-columned Hollyhock House designed by Frank Lloyd Wright. But its marquee attraction—an unfettered view of the Hollywood sign and Griffith Observatory—is available year-round

View from atop Barnsdall Park

to anyone who wants to drive or walk up the steep entryway near the corner of Hollywood and Vermont. The brainchild of oil heiress Aline Barnsdall, the park was intended to be an all-inclusive arts community, but financial and artistic differences between Barnsdall and Wright reportedly got in the way. Today, whimsical metal sculptures, rows of pine trees, and several ice-cream-parlor–style tables and chairs make the courtyard an inviting place.

With a book or a takeout lunch in tow from a nearby eatery along Vermont Avenue, you are all set to escape the hubbub

of East Hollywood. During the day, I rarely see more than a handful of people enjoying the shade and the views. A recent sampling included a man playing checkers with his children, a University of Southern California student (according to the T-shirt) stretched out in the sun with a magazine, and a young woman absorbed in a sketchbook. Perhaps because the gray cast of Hollyhock House makes the park seem on the bleak side—or perhaps because the raised location keeps it hidden from the street—this overlooked gem doesn't get the attention it deserves. (That is good news for tranquility seekers.) Still, you should not leave without walking around Hollyhock House; from its perimeter, you'll be rewarded with great views of the downtown skyline to the southeast.

essentials

4814 Hollywood Boulevard, Los Angeles, CA 90027 (323) 644-6269

barnsdall.org $ Free Daily, sunrise–sunset

Metro Rail Red Line to Vermont/Sunset

Stretch out under a pine tree in the park's courtyard.

peaceful place 11

BERGAMOT STATION

Santa Monica (MAP 4)

CATEGORY ⌣ museums & galleries ✪ ✪

*T*he first peaceful feeling you will get when you drive into this complex of art galleries comes from the ease with which you'll find a parking space. Once home to a train station, a celery-packing operation, and an ice-making plant, it retains an

industrial feel that goes against the suntan-and-beaches vibe for which Santa Monica is known. But as you start to poke around, it's obvious that something interesting is going on behind all the grayness and steel, and it practically begs you to putter about. Home to about 30 galleries, a cafe, and the Santa Monica Museum of Art, Bergamot offers a wonderful respite for an art lover to spend a weekday afternoon. (Saturdays tend to be a little busier, though not nearly at the levels of the Getty or other art museums.)

Begin your visit just west of the parking lot entrance, and work your way clockwise around

A sun-lit hallway leads to Bergamot's art galleries.

the complex. The offerings range from a unique gift shop (Gallery of Functional Art) to a tiny decorative paper store (Hiromi International) to dozens of galleries with rotating exhibits of contemporary art, photography, and multimedia. The standoffish attitude of some gallery staffers just adds to the do-what-you-want freedom the whole place exudes. Make time for a late lunch at Bergamot Cafe, where you can order homemade soup, fresh salads, or smoothies and sit out on the large terrace (once a loading dock for water heaters). It's just the place for reading a book or eavesdropping on conversations about the latest opening-night events.

essentials

2525 Michigan Avenue, Santa Monica, CA 90404

(310) 586-6488

bergamotstation.com

$ Free

Most galleries open Tuesday–Friday, 10 a.m.–6 p.m.; Saturday, 11 a.m.–5:30 p.m.; cafe opens 9 a.m. Monday–Friday and 10 a.m. on Saturday

Big Blue Bus Lines 7 or 11

peaceful place 12

BEVERLY HOT SPRINGS SPA
Koreatown (MAP 1)

CATEGORY ⌣ shops & services ✪ ✪ ✪

*D*eep-tissue massage—as well as body scrubs, facials, and all the usual treatments—is on the menu at the Beverly Hot Springs spa. But what I love most about this no-frills facility near busy Western Avenue is that you can take a nap just when you want it the most: after soaking in the natural spring–fed pools or after getting kneaded and scrubbed until your limbs turn to jelly. The relaxation nook off

Unwind at Beverly Hot Springs Spa.

the women's pool area has three lounge chairs, dimmed lights, and a no-talking policy. A nearby running waterfall adds to the kitschy Costa Rican rain forest ambience.

If you don't want to pay for a specific treatment (though the 30-minute body scrubs are divinely invigorating), an entrance fee of $30 to $40 includes use of the hot and cold pools, a tiny sauna, and a locker room and lounge with sofas and gas fireplace. The pool area can get quite busy, especially on weekends, but weekday mornings and Saturday or Sunday evenings are often less crowded. (Women's facilities are on the main level, with separate men's facilities upstairs.)

essentials

308 North Oxford Avenue, Los Angeles, CA 90004

(323) 734-7000 beverlyhotsprings.com

$ Entrance fee $30 weekdays, $40 weekends (entrance fees are waived with any body treatment)

Daily, 9 a.m.–9 p.m. Metro Bus Local Lines 175 or 207

peaceful place 13

BLUE RIBBON GARDEN, WALT DISNEY CONCERT HALL

Downtown Los Angeles (MAP 1)

CATEGORY ↩ urban surprises ✪

The Frank Gehry–designed concert hall quickly became one of L.A.'s most recognized landmarks when it opened in 2003. Architecture lovers like to study its vaulting steel curves from the street, and classical music fans can experience its state-of-the-art acoustics during performances of the Los Angeles Philharmonic. But it is the Blue Ribbon Garden that offers some of the most interesting views of the concert hall and other downtown buildings. The garden also offers a soft, romantic contrast to all the sharp angles and stainless steel. Perched three floors above street level, and accessible to the public, the setting is Gehry's nod to principal donor Lillian Disney (wife of Walt) and her love of gardening. Mature Chinese pistache, coral, and Hong Kong

A mosaic fountain anchors the concert hall's secret back garden.

orchid trees frame the large mosaic fountain, a centerpiece created from crushed delft china. Dense herb and flower beds almost overflow onto the walkways.

Pick up a drink or snack at the better-than-average cafe inside the lobby, and head up to the garden via the First Street stairs. Office workers often take over the tables during weekday lunch hours, and concertgoers fill the space in the evenings during the Philharmonic season. For the quietest times, plan a visit after 2 p.m. on weekdays, when the lunch crowd returns to the office, and the audio tours, which include a stop in the garden, have concluded for the day. Weekends are also relatively quiet, unless a wedding is on the agenda. The garden is accessible from the concert hall's third floor or by stairs and an elevator off First Street.

⌣ˑ essentials

⌷=˙⌷ 111 South Grand Avenue, Los Angeles, CA 90012

𝓒 (213) 972-4399 🌐 laphil.org

$ Free access to garden; audio tours $12 (available non-matinee weekdays 10 a.m.–2 p.m.)

🕐 Daily, though sometimes closed for private events

🚌 Metro Rail Red Line to Civic Center; DASH Route A or B

peaceful place 14

BONJUK

Koreatown (MAP 1)

CATEGORY ⌣ quiet tables ✪ ✪ ✪

The porridge is seriously good, but it is the hushed atmosphere of this small Korean restaurant that will comfort you like a fresh-laundered blanket. Even when most of the tables are filled, it's so quiet that the occasional clang of metal chopsticks seems jarring, and the background music is tamer than the strains in your average elevator. It's a good place to go for an uninterrupted conversation with a friend or for a quiet solo lunch if you happen to be near the Wilshire Corridor office district. Even the high-backed

Porridge and tranquility are the specialties at Bonjuk.

chairs, upholstered in robin's-egg blue, are agreeable and calming. *Juk* means porridge in Korean, and that's what you will find on the menu: about a dozen different kinds.

One portion of *juk* easily satisfies two people. I like the silky pumpkin porridge with rice dumplings; others swear by the *jeonbokjuk* (abalone porridge) as the perfect hangover cure. Regardless of your choice, it comes with unlimited cups of tea. One of several *juk* restaurants in Koreatown, Bonjuk is a branch of a Korean-based chain and is located on the ground floor of a nondescript office building. The restaurant's newcomers will appreciate blow-up photos of the different varieties of porridge displayed above the doorway, and Korean pop magazines are handy for more insights into this remarkable culture.

essentials

3551 Wilshire Boulevard, Los Angeles, CA 90010

(213) 380-2248

bonjuk.com

$ Varies according to menu selection; bowls of *juk*, $8–$16

Monday–Friday, 7 a.m.–10 p.m.; Saturday, 8 a.m.–10 p.m.; Sunday, 8 a.m.–9 p.m.

Metro Rail Red Line to Normandy/Wilshire

peaceful place 15

BOOKMARK CAFÉ

Santa Monica Public Library, Santa Monica (MAP 4)

CATEGORY ᴗ˸ quiet tables ✪ ✪

*Y*ou've got to love a library that has a fiction section with its own garden and more than 200 Criterion Collection films in its DVD database. So it should come as no surprise that Santa Monica's snazzy new library also has a fabulous cafe to go with its sustainable landscaping and sunlit rooms. Located in the central courtyard and directly accessible from Seventh Street, the cafe is a very pleasant place to grab lunch—whether or not you spend time amid actual bookshelves. Most of the two dozen umbrella-shaded tables are outside and flank a desert garden and water feature. The latter brings to mind the ocean, which is only five blocks away.

The least crowded times are typically before the library opens (see hours at right), but even during the lunch rush, the courtyard is a relaxing place to eat, read, or hunker down with a laptop. An underwater-themed

Outdoor patio at Bookmark Café

canopy casts playful shadows on the tables, and reverence for the proximity to so many books seems to keep cell phone gabbers and noisy kids in check. The cafe menu includes everything from Texas chili and bacon avocado cheeseburgers to veggie wraps and smoothies. Another bonus: You can park in the library's large underground lot for $0.50 per half hour with a maximum charge of $7 (no validation required). Enter on Seventh Street.

essentials

601 Santa Monica Boulevard, Santa Monica, CA 90401

(310) 587-2665 smpl.org $ Menu items, $4–$8

Monday–Thursday, 8:30 a.m.–9 p.m.; Friday, 8 a.m.–5:30 p.m.; Saturday, 9 a.m.–5:30 p.m.; Sunday, 11:30 a.m.–5 p.m. (The cafe opens one to two hours ahead of the library, according to the day of the week, but observes the same closing hours.)

Big Blue Bus Lines 1, 2, or 3; Metro Bus Local 10

peaceful place 16

BOURGEOIS PIG
East Hollywood (MAP 2)

CATEGORY ⌣ quiet tables ✪ ✪

his hip coffeehouse is one of the rare places in L.A. that hide from, rather than embrace, the bright sun. In fact, it is usually so dark that your eyes will need a few minutes to adjust upon entering. Your ears will tell you that you've arrived, however, as it's not the quiet-est of places for reverie. The likes of White Stripes or Beatles music dominates the room, and an espresso machine hisses over and over. But you can partake of a slightly quieter and even more isolated experience if you seek out the comfortable couches in the cavelike back room to the right of the pool table.

Regardless of where you are sitting, the Pig offers free Internet access, an unhurried vibe, and multiple electrical outlets for keeping the laptop charged. Thus, it's a haven for screenwriters and actors who live in the area of Beachwood Canyon or Los Feliz. The estate-sale decor

Seek out the back room for the quietest experience.

includes extra-wide tables, antique sofas, mismatched chandeliers, and slate-gray walls that remind me of the color of the ocean at dusk. The front room has great views of the Church of Scientology's leafy Celebrity Centre across the street, so your eyes can latch onto that scene while your mind wanders aimlessly. Or from this room you can lazily watch the passing parade of cars and people along Franklin Avenue. Nighttime, however, brings the couples and bar-goers seeking last-call lattes, so stick with daytime if you want to get some work done or to experience the place at its noirish best.

✎ essentials

✉ 5931 Franklin Avenue, Los Angeles, CA 90028

☎ (323) 464-6008 ✈ N/A

$ Varies according to menu selections; coffee drinks, $3–$5

🕐 Daily, 9 a.m.–2 a.m.

🚌 Metro Rail Red Line to Hollywood/Western; Hollywood DASH; Metro Bus Local 207 or 181

peaceful place 17

BRADBURY BUILDING LOBBY

Downtown Los Angeles (MAP 1)

CATEGORY ⌣ historic sites ✪ ✪

*V*isitors with no particular reason to be in the Bradbury Building other than to look aren't permitted to spend much more than five minutes inside. But trust me: It's enough time to leave an impression that will last a lifetime. Built in 1893, the Bradbury is downtown's oldest commercial building, as well as one of the city's most beloved landmarks. The sunlit five-story atrium transports you to another era with its glazed-brick walls, open-cage elevators, and wrought-iron railings. You'll find such ornate beauty completely unexpected after navigating the souvenir shops and fast-food chains now omnipresent in this Broadway neighborhood.

Film buffs will immediately recognize the interior as the setting for the final battle between characters played by Rutger Hauer and Harrison Ford in

The Bradbury Building's atrium

Blade Runner. Ditto for Fred MacMurray's office in *Double Indemnity.* While the lobby always appears ready for its close-up—and is still often used for film shoots—office workers streaming to and fro bring a kind of buzzing normalcy to the day-to-day setting, except on weekends. Then it's usually just you and a security guard (who doesn't mind discreet lingering), and that's when the architectural gem is at its most hushed and magical. Before you scoot out, be sure to take note of the life-size sculpture of Charlie Chaplin, whose film *City Lights* premiered at the Los Angeles Theatre across the street, behind the lobby.

⌣ essentials

304 South Broadway, Los Angeles, CA 90013

(213) 626-1893 N/A $ Free

Daily, 9 a.m.–6 p.m., except during film shoots

Metro Rail Red Line to Pershing Square; DASH Route B or D

peaceful place 18

CABRILLO BEACH
San Pedro, South Bay (MAP 5)

CATEGORY 〰 outdoor habitats ✪

A short drive away from the fried-fish stands and mariachi bands of Harbor Boulevard's Ports O' Call Village sits one of L.A.'s best and most melancholy stretches of sand. If you time it right (that is, avoid summer weekends), you may have to share the place with only a parking lot attendant and the cargo ships and fishing boats chugging in and out of the harbor. At the southernmost tip of the blue-collar port town of San Pedro, Cabrillo meets all the requirements for the perfect

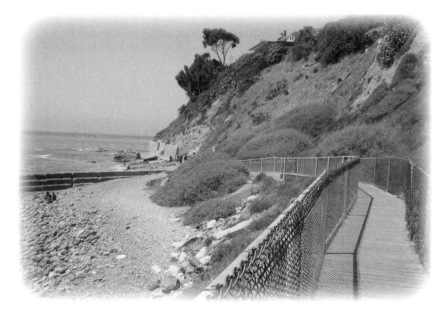

Follow the Cabrillo Beach walkway to a hidden rocky cove.

walking beach: a picturesque jetty, fringes of palm trees, a 1930s Art Deco bathhouse, and dueling views—the Vincent Thomas Bridge and bright blue cranes on one side of the peninsula, and Catalina Island on the other.

Even during the peak summer season, when group baptisms and extended family reunions seem to take over, it's possible to find a quiet place to hang out. Follow the fenced wooden walkway near the Stephen M. White parking lot entrance to a rocky cove that marks the beginning of the Point Fermin Marine Life Refuge. Stretch out on one of the concrete barriers, or just sit on the rocks and gaze at the ocean. The nostalgic wail of distant ship horns and laughter from nearby volleyball games pleasantly punctuate the seaside silence.

essentials

☰ 3720 Stephen M. White Drive, San Pedro, CA 90731

✆ (310) 290-0049 🌐 sanpedro.com

$ $1 an hour parking, maximum of $7–$9, depending on the season

🕐 Daily, 7 a.m.–10 p.m. 🚌 Metro Bus Local Line 246

peaceful place 19

CAMERA OBSCURA
Palisades Park, Santa Monica (MAP 4)
CATEGORY ⌣ historic sites ✪ ✪ ✪

*N*ear the base of the Santa Monica Pier sits a mid-20th-century senior recreation center with million-dollar ocean views and a small sign on the front door: CAMERA OBSCURA UPSTAIRS. Hand over a picture ID to the person in the office, and you will be given a key and pointed upstairs to a dark, quiet room fitted with a century-old optic device that projects images of the bustling beachfront outside. A ship's wheel lets you rotate the camera to get 360-degree views of the ocean, palm trees,

The mid-20th-century quarters of Camera Obscura

high-rise Ocean Avenue condos, and facial expressions of every tourist and exercise hound swarming Palisades Park on a sunny day.

Built in 1898 and one of only a handful still in existence (another one is in San Francisco), the Camera Obscura was moved inside the senior center in 1955 and has remained one of Santa Monica's quirkiest attractions ever since. On your way upstairs, don't be surprised if you pass the city's age-60-and-up residents playing bingo or digging into a lunch buffet of pasta and fruit salad. Once you have shut the door, though, the pitch-black room cocoons you from the beachfront hubbub outside and lets you enjoy those classic SoCal views in absolute quiet.

✎ essentials

📧 1450 Ocean Avenue, Santa Monica, CA 90407

📞 (310) 458-8644

🌐 santamonica.com

$ Free

🕐 Monday–Friday, 9 a.m.–4 p.m.; Saturday–Sunday, 11 a.m.–4 p.m.

🚌 Big Blue Bus Lines 7 or 10

peaceful place 20

CATHEDRAL OF OUR LADY OF THE ANGELS
Downtown Los Angeles (MAP 1)

CATEGORY ↙ spiritual enclaves ✪ ✪

*A*t first glance, there's nothing cozy or tranquil about the modern concrete building that looms like a big-box store over the Hollywood Freeway. Stretching 12 stories high, the mother church of the Los Angeles Archdiocese can accommodate 3,000 worshipers in its main sanctuary. But every Wednesday following noon Mass, the cathedral hosts an organ recital that transforms the massive space into a haven of awe-inspiring serenity. The music flows from the organ's 6,019 pipes and reverberates throughout the building, from the front pews to the crystal chandeliers.

The seats that face either side of the altar are my favorites because there is less distracting foot traffic, but the music's pure vibrations can be heard from anywhere on the cathedral's main floor. After the concert,

Savor the music at the cathedral's weekday organ recitals.

walk across the sun-baked plaza to the shady children's garden near the on-site cafe. With benches, whimsical bronze animal statues, and a surprising lack of frolicking children this time of day, it's a good place to savor the experience before returning to the hectic downtown streets.

⌣ essentials

▭ 555 West Temple Street, Los Angeles, CA 90012

☏ (213) 680-5200

🌐 olacathedral.org

$ Free, but contributions to the offering box are welcome

🕐 Recitals every Wednesday, 12:45 p.m.–1:15 p.m.

🚌 Metro Rail Red Line to Civic Center; DASH Route B

peaceful place 21

THE CHARLIE

West Hollywood (MAP 3)

CATEGORY ⌣ day trips & overnights ✪ ✪ ✪

*S*aying that Charlie Chaplin spent time in a specific house or studio in L.A. is a bit like hanging a sign stating "George Washington slept here" in the eastern United States. The Little Tramp spent nearly 40 years drinking, sleeping, writing, and making movies all over the city. The latest venue to claim Chaplin as a likely resident is an idyllic little inn off a West Hollywood side street. Actresses Marilyn Monroe and Gloria Swanson are also believed to have spent quality time here in the 1940s and '50s. It's easy to see why: Owner Menachem Treivush restored the 14 cottages to their original storybook charm in 2008, and the cottages surround a leafy garden courtyard with fountains, pathways, and an outdoor fireplace.

The small complex sits within walking distance of many Santa Monica Boulevard shops

A courtyard garden hides The Charlie's cottages.

and restaurants, and is a five-minute cab ride from the Sunset Strip. Yet once you close the front gate, you feel completely sequestered from the outside world. The place is also known for its discreet (but always available) customer service, which may explain its attraction to celebrities such as Liv Tyler and Kristen Stewart. Despite the celeb factor, The Charlie is not the least bit intimidating and should be considered by any Southern Californian looking to splurge on a one- or two-night getaway close to home. Chaplin is believed to have written *The Gold Rush* in Room 823¼ (also known as Charlie Cottage); lesser mortals can watch the silent film on a flat-panel TV during their stay.

⌣ essentials

819 North Sweetzer Avenue, West Hollywood, CA 90069

(323) 988-9000

thecharliehotel.com

Rooms $350–$600 daily; weekly and longer-term rates available

Open year-round

Metro Bus Local Line 10

peaceful place 22

CHERRY CANYON PARK

La Cañada Flintridge, San Gabriel Valley (MAP 8)

CATEGORY ↴ outdoor habitats ✪ ✪ ✪

*C*herry Canyon Park is carved into the San Rafael Hills just behind Descanso Gardens, a peaceful destination in its own right. The Santa Monica Mountains Conservancy and the city of La Cañada Flintridge helped to preserve the park in the mid-1980s. A handful of well-maintained trails spread like tentacles across its 130 acres and yield great views of downtown L.A. and the San Gabriel and Verdugo mountains. I like to start by following the Owl Trail through a forest of mature oaks and sycamores before picking up the exposed fire road that loops around the hillside. The park isn't very big, and most trails tend to reconnect with the main fire road after a mile or two, so don't be afraid to wander off the main path and explore any unmarked trails that catch your eye. I love to hike Cherry Canyon on cool, overcast mornings since there is little shade, and the fog rolling across the green hills makes the trails even more serene and scenic. This is a gem of a neighborhood park that is rarely crowded.

↴ essentials

- ✉ 4157 Hampstead Road, La Cañada Flintridge, CA 91011
- ✆ (818) 790-8880 ⊕ lamountains.com $ Free
- 🕐 Daily, sunrise–sunset 🚍 N/A

peaceful place 23

CHINESE AMERICAN MUSEUM

Downtown Los Angeles (MAP 1)

CATEGORY ↝ historic sites ✪ ✪

To get to the Chinese American Museum, walk through the Olvera Street plaza and look for the hanging red lanterns. At first the neat redbrick building may seem out of place amid the touristy Mexican heritage themes of El Pueblo de Los Angeles. But once inside, you will realize that it couldn't be in a more appropriate place. The three-story 1890s building is the oldest and last remaining structure from L.A.'s original Chinatown, which was moved in the 1930s to make room for Union Station and the 101 freeway.

Hushed and sleek with polished hardwood floors, the space includes an exhibit of old photos humanized by quotations and oral histories. A re-creation of an actual general store and herb shop is complete with an apothecary cabinet and regular appearances by a former clerk. On the upper floors, rotating exhibits showcase prize-winning

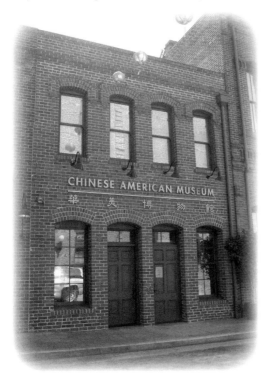

A historic building houses the Chinese American Museum.

student artworks or the history of Chinese Americans in film. At 7,500 square feet, it is one of L.A.'s smaller museums, but its peacefulness (and on hot days, its generous use of air-conditioning) makes you want to linger and learn. Children are welcome and, thanks to plenty of hands-on exhibits, not likely to be bored—but to remain peaceful themselves.

⌣ essentials

✉	425 North Los Angeles Street, Los Angeles, CA 90012
☎	(213) 485-8567
🌐	camla.org
$	$3 suggested donation
🕐	Tuesday–Sunday, 10 a.m.–3 p.m.
🚌	Metro Rail Yellow, Red, or Purple Line to Union Station; DASH Route B or D

peaceful place 24

CRYSTAL COVE STATE PARK

Laguna Beach (FARTHER AFIELD: MAP 9)

CATEGORY ⌣ outdoor habitats ✪ ✪

*C*all it the polar opposite of Huntington Beach: no picnic tables, no volleyball nets, no family-size tents, and no barbecue pits. Marked by 50-foot cliffs and photogenic tide pools, Crystal Cove is a remarkably clean 3-mile stretch of sand that is perfect for walking, especially at twilight. Its north end was a colony of cottages and tents in the 1930s and '40s, hopping with Prohibition-busting luaus and a festive beach air. Today, the state rents the restored cottages for up to seven nights to a lucky few who

Cooling off at Crystal Cove State Beach

manage to snag the sought-after reservations that are made available up to 60 days in advance. The main beach is a mile or so south of the cottages: Day-trippers may park in the large lot, then descend a steep but manageable flight of stairs to the beach. Once your toes hit the sand, you will completely forget about the Pacific Coast Highway traffic you just abandoned. Large cliffs act as a natural buffer from the busy road and also obscure the view of the large upscale housing development across the street. Parking will set you back a cool $15 per car, but access to this breathtaking beach is worth every penny.

⌣ essentials

⌸ 8471 North Coast Highway, Laguna Beach, CA 92651

☏ (949) 494-3539

⌖ crystalcovestatepark.com for general information; crystalcovebeachcottages.com for more on cottage rentals

$ Cottage rooms and cottages: $65–$323 per night; $15 day-use parking

☉ Daily, sunrise–sunset

🚌 Orange County Transit Authority Bus Route 1

peaceful place 25

DOMINGUEZ RANCHO ADOBE MUSEUM
Compton, South Bay (MAP 5)

CATEGORY ⌄ historic sites ✪ ✪ ✪

he hilltop landmark truly deserves to be called an oasis—smack in the middle of a sterile industrial and commercial stretch near the borders of Carson and Compton. The adobe sits on the site of the first Spanish land grant in California and

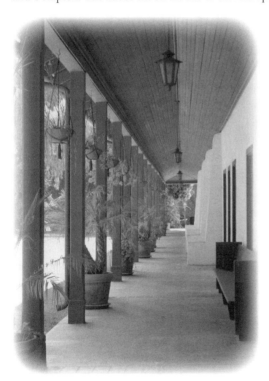

The Adobe's back veranda

remains a remarkable hideaway of rolling hills, century-old trees, gardens, and Spanish-style architecture. When the king of Spain bestowed the land on retired soldier Juan Jose Dominguez in 1784, the parcel stretched as far as the Palos Verdes Peninsula. The descendants of Dominguez still run the homestead and its remaining acreage; lucky for us, they open the grounds to the public every day and its house to tours twice a week.

The grounds—with cacti and rose gardens, a picnic area, and a front lawn so pristine that it could host polo matches—are reason enough to visit, especially when you bring lunch and have

a couple of hours to linger. For an even more satisfying experience, time your visit to coincide with one of the free 45-minute tours of the thick-walled ranch house. Besides a peek at original 1800s-era furniture carted here by ship from South America, the tours cover the Dominguez family's history and how it is connected to current landmarks such as the Del Amo Fashion Center and the city of Carson. There's even an entire room devoted to the first international aviation meet, which was held at the Adobe in 1910 and attended by a young William Boeing. You will leave here with not only a sense of tranquility, but also a better understanding of the intertwined role of Mexico, Spain, and the land called America in California's history.

⌣ essentials

⌂ 18127 Alameda Street, Rancho Dominguez, CA 90220

☏ (310) 603-0088 🌐 dominguezrancho.org $ Free

🕐 Grounds: Daily, 9 a.m.–5 p.m.; House: Open for tours Wednesday and Sunday beginning at 1 p.m.

🚌 Metro Bus Local Line 60

peaceful place 26

DUFFY BOATS

Marina del Rey, Long Beach, and Newport Beach (MAPS 4, 5, AND 9)

CATEGORY ↙ urban surprises ✪ ✪ ✪

*T*he outfits that rent these super-quiet, smooth-sailing, battery-powered boats like to compare them to golf carts—and it's easy to understand why. In fact, the inventor, Marshal "Duffy" Duffield, came up with the idea when he experimented with a golf cart motor in an old motorboat back in the 1970s. His adaptation worked, and now the easy drive takes place around the harbor instead of the country club grounds. Modern versions of his originals are a bit like limousines in that they come equipped with padded seats, CD players, ice buckets, and enough table room for a picnic feast if you wish. They are a frequent sight in the harbor communities of Marina del Rey, Long Beach, and Newport Beach. In all three places, you can rent them by the hour.

A Duffy boat anchored in Long Beach harbor

While some of the boats seat up to 12 people and are popular

for birthdays and other celebrations that might warrant something special, smaller ones are comfortable for a couple seeking some quiet, romantic time on the water. You'll quickly forget the crowds of Long Beach's Shoreline Village or Newport Beach's Balboa Island. One minute you're walking through a noisy video arcade or you're in a bumper-to-bumper hunt for parking, and the next you're gliding around at 7 miles an hour with a Manhattan in one hand and shrimp cocktail in the other. Newport Beach rental shops provide harbor maps and let you preorder food from waterfront restaurants that will deliver to you dockside.

In all three locations—Marina del Rey, Newport Beach, and Long Beach—reservations aren't necessary, but they are recommended for weekends and holidays such as the Fourth of July and Christmas. (Not good times for peacefulness seekers anyway.)

↴ essentials

🖃	13719 Fiji Way, Marina del Rey, CA 90292; 429 Shoreline Village Drive, Long Beach, CA 90802; 2001 West Pacific Coast Highway, Newport Beach, CA 92663
☏	Marina del Rey: (310) 574-2822; Long Beach: (562) 491-7400; Newport Beach: (949) 645-6812
🌐	boats4rent.com or duffyofnewportbeach.com; for more of the interesting background on these electric boats, visit duffyboats.com
$	Rentals start at $85–$99 an hour
🕐	Daily in summer; call ahead for off-season hours
🚌	N/A

peaceful place 27

EL MATADOR BEACH

Malibu (MAP 6)

CATEGORY ⌣: outdoor habitats ✪ ✪

*O*ne of three pocket beaches that make up Robert H. Meyer Memorial State Beach, El Matador is the first one that you hit while driving west on the Pacific Coast Highway. As soon as you see its rocky outcrops and 100-foot bluffs from the edge

A Malibu beach without the crowds

of the parking lot, you will know that there's no need to continue on to its sister beaches, El Pescador and La Piedra. With its huge picturesque boulders and hidden caves, El Matador has *Sports Illustrated* swimsuit issue written all over it. Yet it's surprisingly quiet and uncrowded, even when nearby beaches at Point Dume and Leo Carrillo are packed. Perhaps that's because it requires descending two flights of steps and a steep path to reach the sand. Believe me: It's worth the effort. This beach is ideal for sunbathing, strolling, and poking around sea caves, though swimming can be hampered by heavy doses of seaweed

and kelp. Just be very careful not to get caught here at high tide, when waves sometimes reach the base of the cliffs.

⌣ essentials

▤	32215 Pacific Coast Highway (PCH), Malibu, CA 90265
✆	N/A
🌐	parks.ca.gov
$	$8 to park in the lot; free to park along the PCH
🕐	Daily, 8 a.m.–sunset
🚌	Metro Bus Local 534

peaceful place 28

ERNEST E. DEBS REGIONAL PARK

Highland Park, Northeast Los Angeles (MAP 8)

CATEGORY ↵ scenic vistas ✪

The Scrub Jay Trail in Debs Park begins with the unmistakable sound of cars whooshing by on the Arroyo Parkway. Within 10 minutes, however, the path disappears into a forest of chaparral and hooks up with the wide and winding Walnut Forest Trail. This trail elevates you to a mountain ridge, where you'll take in lofty views of Highland Park and Montecito Heights. Don't be tempted to turn around yet, because another half-mile's walk brings you to a tree-and-boulder-framed pond—a reservoir, actually—with vistas to Chavez Ravine and downtown Los Angeles. Altogether 3 miles round-trip, this excursion is one of my favorite hikes in Los Angeles, largely because it leads to this unexpected and peaceful rest stop by the water. A couple of benches and large rocks provide places to sit (or to fish for largemouth bass and bluegill), and you will usually sight more red-tailed hawks and butterflies than humans in the vicinity.

The reservoir can also be reached by an easy half-mile walk from the park's 4235 Monterey Road entrance, but then you would be missing out on visiting the Audubon Center (where the Scrub Jay Trail starts). One of L.A.'s greenest buildings, the center offers environmental displays, postings of recent animal and bird sightings, and a terrific children's garden with a playhouse and water pump. The center is a great place to begin and end your experience in this unexpected slice of nature in the middle of the city.

essentials

▭ 4700 North Griffin Avenue, Los Angeles, CA 90031

☎ (323) 221-2255

🌐 audubondebspark.org

$ Free

🕐 Park: Daily, sunrise–sunset; Audubon Center: Tuesday–Saturday, 9 a.m.–5 p.m.

🚌 Metro Rail Gold Line to Southwest Museum

peaceful place 29

EXPOSITION PARK ROSE GARDEN

Downtown Los Angeles (MAP 1)

CATEGORY ↩ parks & gardens ✪

ublic rose gardens abound in L.A., but this one stands out for its sweet scent and roomy Alice-in-Wonderland layout. It's also very big, to the tune of 200,000 roses—more than 200 varieties of them. Surrounded by the Museum of

More than 200 varieties of roses grow in Exposition Park.

Natural History, the California Science Center, and the University of Southern California, it also is conveniently located for leisure activities. Opening in 1928, the garden reportedly replaced grounds once used for dog-, horse-, and camel-racing. Today, instead of a racetrack, you'll find a large central fountain, four gazebos, and many tree-shaded corners. The Los Angeles Department of Recreation and Parks maintains the place well enough. While staff at other public gardens often pounce on anyone who strays from the designated paths, this one is so laid-back that you can pretty much run barefoot

through it or throw down a blanket and hang out for the entire day without anyone noticing. Tips: Expect lots of wedding-photo ops on spring weekends, and don't ever plan a visit during a USC Trojans game, since the Coliseum is a block away.

⌣ essentials

✉	701 State Drive, Los Angeles, CA 90037
☏	(213) 763-0114
🌐	laparks.org/exporosegarden/rosegarden.htm
$	Free; $7 to park in the Exposition Park lot
🕐	Daily, 9 a.m.–sunset (always closed January 1–March 15 for maintenance)
🚌	Metro Bus Express Line 550, Rapid Line 740 or 745; Local Line 42A, 45, 81, or 200; DASH Route F

peaceful place 30

FARMERS MARKET

Third Street and Fairfax Avenue, West Los Angeles (MAP 3)

CATEGORY ↝ quiet tables ✪ ✪

*C*all it the world's coolest food court. The Farmers Market at Third and Fairfax, known as "Farmers Market, the Original," is a charming old jumble of mom-and-pop bakeries, fresh produce stands, souvenir shops, and eateries that in 2002 found itself attached to an upscale shopping complex known as The Grove. The layout of its tables, however, is as unusual as the 75-year-old market itself, so when you want to find a table to settle down with your shrimp po'boy from the Gumbo Pot or mushroom tacos from Loteria

Stairs lead to a quiet eating room at the Farmers Market.

Grill, your options may seem limited to the large, noisy sitting areas that anchor either end of the market, or tables that sit smack in the middle of busy pedestrian thoroughfares.

However, few people realize that a rarely crowded sanctuary, perfect for watching the hubbub below, is right above them. Look for the signs for "More Tables" near Kip's Toyland and the *churrascaría,* and follow the stairs up to a large skylit area. There, the tables near the windows overlook the entrance to the market and catch breezes that waft through on temperate days. On summer Thursdays, sounds of live music drift up from the patio below. Altogether, it makes for an unexpectedly relaxing situation. Before you leave, check out the black-and-white photos of market merchants that line the wall; they are testament to the market's staying power and its important place in Los Angeles history.

⌣ essentials

⌐≡̇⌐ 6333 West Third Street, Los Angeles, CA 90036

𝘊 (323) 933-9211 🌐 farmersmarketla.com

$ Free access for strolling about; menu prices vary according to vendor and selection

🕐 Year-round, Monday–Friday, 9 a.m.–9 p.m.; Saturday, 9 a.m.–8 p.m.;
Sunday, 9 a.m.–7 p.m.

🚌 Metro Bus Local Lines 14 or 16

peaceful place 31

FERN DELL

Griffith Park, Los Feliz (MAP 2)

CATEGORY ↝ enchanting walks ✪ ✪

*L*iving up to its name, the shady quarter-mile trail is one of the best places to be in Los Angeles on a blazing-hot summer afternoon. Near the western entrance to Griffith Park, off Los Feliz Boulevard, it loops around a surprisingly

Follow Fern Dell's shady path.

robust creek marked by a series of small waterfalls (my family and I counted 23). A canopy of sycamores and pines and dozens of varieties of ferns surround you with natural sunblock and air-conditioning.

For a peaceful time with small kids, take them here, as they can easily navigate the path and the small bridges. The dell is equally appealing to dog walkers, the occasional runner, and hand-holding couples. I like to park across from Trails Café (2333 Fern Dell Drive), then follow the path south under the road and into the dell. Afterward, the vegan-friendly cafe—actually a snack stand with outdoor picnic

tables—lures me with its house-made iced tea and a slice of mushroom-cashew pie. Parking can be challenging on weekends, but Fern Dell usually remains a hidden respite from crowds and noise.

essentials

📧 5375 Red Oak Drive, Los Angeles, CA 90027 📞 (323) 913-4688

🌐 laparks.org/dos/parks/griffithpk/ferndell.htm

$ Free 🕐 Daily, sunrise–sunset

🚌 Metro Rail Red Line to Hollywood/Western

A waterfall at Fern Dell

peaceful place 32

FIGUEROA HOTEL

Downtown Los Angeles (MAP 1)

CATEGORY quiet tables ✪ ✪

The Figueroa's Veranda Bar at night may be the least intimidating beautiful cocktail spot in L.A. Its long, grand entryway from the hotel lobby sets the tone

Veranda Bar at night

for the Veranda's exotic Moroccan theme. Instead of DJs and bouncers, you'll find an ornate tiled bar, plenty of seating, and a variety of patrons, from office workers to post-game Lakers fans, sipping mojitos or blue martinis and having intimate poolside conversations. After dark (the later the better) is the best time to visit, when the blue pool shimmers in the moonlight, flickering candles provide dim lighting, and the hovering skyscrapers and laser lights emanating from nearby L.A. Live remind you that you haven't completely traded the City of Angels for North Africa. It can be challenging to place a drink order, but that also means there's little pressure to rush once you settle in

for a romantic night. A limited food menu is offered, but this spot is better for a cocktail or nightcap.

⚘ essentials

⌨ 939 South Figueroa Street, Los Angeles, CA 90015 📞 (213) 627-8971

🌐 figueroahotel.com $ Cocktails, $6–$12

🕐 Sunday–Thursday, 6 p.m.–midnight; Friday–Saturday, 6 p.m.–2 a.m.

🚌 Metro Rail Red or Blue Line to Seventh Street/Metro Center; DASH Route F

A romantic spot for a nightcap

peaceful place 33

FIRST CONGREGATIONAL CHURCH OF LOS ANGELES

Koreatown (MAP 1)

CATEGORY ⌣ spiritual enclaves ✪ ✪ ✪

ust when I thought that I had been to every place worth visiting in the City of Angels, I attended a midday organ concert in this cool Gothic sanctuary near MacArthur Park. Dark, soaring, and reminiscent of a European cathedral, it is home to

Gothic church in Koreatown

the world's largest church pipe organ and isn't stingy about sharing its good fortune with the rest of the city. The free concerts, held just past noon on Thursdays and before Sunday services by resident organist S. Wayne Foster, are as thunderous and all-absorbing as you would imagine that an instrument with 20,000 pipes might be.

Whether Foster is playing Bach or Beethoven, Sowerby or Boëllman, the 45-minute program is often thoughtfully tied to a current theme or holiday. The turnout is usually robust and ranges from church members and neighborhood residents to Hawaiian-shirted tourists and

hand-holding couples. But you can ignore the crowd and lose yourself in the music. Then enjoy your own bag lunch in the front courtyard in the shadows of the massive main tower. They don't make them like this anymore.

⌣ essentials

✉	540 South Commonwealth Avenue, Los Angeles, CA 90020
☎	(213) 385-1341
🌐	fccla.org
$	Concert is free
🕐	Concert every Thursday at 12:10 p.m. and Sunday 10:30 a.m.–11 a.m.
🚋	Metro Rail Red Line to Vermont/Wilshire

peaceful place 34

FOOT SPAS
San Gabriel (MAP 8)

CATEGORY ⌣ shops & services ✪

The Far Eastern practice of foot massage dates back thousands of years and is based on the belief that nerve endings in the foot are linked to the body's internal organs. Translation: It not only makes your feet feel wonderful, but it also helps your entire body relax. In the mid-2000s (and long after the L.A. foot-massage leitmotif in Quentin Tarantino's 1994 sensation *Pulp Fiction*), salons specializing in the treatment started popping up all over San Gabriel Valley. Competition grew so fierce that the average price dropped to a bargain-basement rate of $15 an hour.

A relaxing foot massage

The bulk of the businesses remain concentrated in strip malls between Del Mar and San Gabriel boulevards along Valley Boulevard. Typically one-room establishments lined with reclining chairs, such retreats are sometimes embellished with plasma TVs, stacks of gossip magazines, and Zen waterfalls. Most include a cup of tea and a robust back

and shoulder rub along with the foot-massage treatments. These services would not be classified as luxury spa experiences, but I find them to be affordable, easy (no reservations required) pick-me-ups when work and family life get a little too tense and rushed. One of the quieter salons is Sole So Good, where dim lighting, soothing music, and an English-speaking owner help provide a stress-free ambience. That salon stays open late and glows with candles in the evening—making it an ideal place to end a busy day and boost your chances of getting a good night's sleep.

⌣ essentials

🖃	Sole So Good Massage Spa, 801 East Valley Boulevard, San Gabriel, CA 91776
☎	(626) 307-1788
🌐	N/A
$	Spa services at Sole So Good start at $20 an hour; other foot spas start at $15 an hour
🕐	Daily, 10 a.m.–11 p.m.
🚌	Metro Bus Local 76

peaceful place 35

FOREST LAWN CEMETERY COURT OF FREEDOM
Glendale (MAP 7)

CATEGORY ⌣ spiritual enclaves ✪ ✪

*F*olks go to the marketing-savvy Hollywood Forever Cemetery for its summer-time night movies, tourist-friendliness (maps are $5 at the gift shop), and cen-

Quiet benches line Forest Lawn's Court of Freedom.

tral location near Paramount Studios. But movie-star buffs and those who appreciate wide-open spaces with their grave-yard visits know that Forest Lawn Cemetery out in Glendale is the place to go. Long before Michael Jackson was buried in the security-tight Great Mauso-leum here, this hillside sanctuary was the final resting choice for a parade of famous people, from Humphrey Bogart and George Burns to Sammy Davis Jr., Clark Gable, and Mary Pickford.

Some may consider the huge stained glass *Last Supper* replica and life-size statues over the top, but the pristine beauty and seren-ity of its grounds are undeni-able. While Jackson's crypt is

strictly off-limits, the public is welcome to drive or walk around other parts of the property.

The Court of Freedom in the cemetery's northeast corner is a good, if grandiose, option. It's home to a 600-square-foot reproduction of John Trumbull's painting *The Declaration of Independence;* a mausoleum; lots of green space and benches; and the graves of Casey Stengal (facing Chavez Ravine, for some reason), Walt Disney, Errol Flynn, and Spencer Tracy. A walled garden hides the graves of the latter three from street view, but the gate is usually open to anyone who walks by. A couple of benches under shade trees allow some time for reflection on life, death, and old Hollywood before you get back in the car with, most likely, a great sense of peace.

essentials

1712 South Glendale Avenue, Glendale, CA 91205

(800) 204-3131

forestlawn.com

Free

Gates open daily

Glendale Beeline Route 1 or 4

peaceful place 36

GALLERY AT THE END OF THE WORLD

Altadena (MAP 8)

CATEGORY ⌣ museums & galleries ✪ ✪

*T*he name of this small art gallery alone deserves a tip of the hat. But owner Ben McGinty has also turned it into a fabulously quirky hub for local art, conversation, and community events. So if your cup of peace sometimes includes mingling with a few artistic souls, this is the place to be.

Located in a Spanish tile–roofed house in the foothills north of Pasadena, the gallery hosts four multimedia art shows a year. Random events include Sunday salons and pot-luck barbecues. Sponsored by a co-op known as the Underground Arts Society, the art

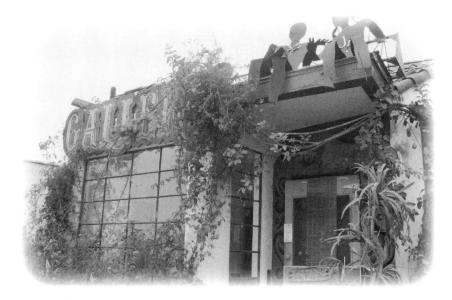

Artworks greet visitors at Gallery at the End of the World.

shows feature works by artists from all over L.A. Dogs are welcome, as are banjo players, sangria sippers, and anyone who wants to hang out for a while in an informal indoor-outdoor setting in the shadows of the San Gabriel Mountains. It's a long trek to get here from West L.A. or the South Bay, so distance travelers might want to combine a visit with a stop at the equally quirky Rancho Bar next door or a sweet-tooth fix at Bulgarini Gelato up the street.

↩ essentials

✉	2475 North Lake Avenue, Altadena, CA 91001; Bulgarini Gelato, 749 East Altadena Drive, Altadena, CA 91001
☎	(626) 794-8779
🌐	galleryattheendoftheworld.com
$	Free
🕐	Times vary; call or check Web site for schedule
🚌	Metro Bus Local Lines 180 or 267

peaceful place 37

GARDENS OF THE WORLD
Thousand Oaks (MAP 6)

CATEGORY ↝ parks & gardens ✪ ✪

*T*he narrow driveway for Gardens of the World sneaks up on you as you make your way past the brown stucco office buildings and strip malls of Thousand Oaks Boulevard. Inside the iron gates lies a sight unusual for this bedroom community just over the San Fernando Valley border: a public park with pristine lawns, gurgling fountains, and a Victorian bandstand big enough to host a *Dancing with the Stars* reunion. Opened in 2001 by the owners of a successful local travel agency, it features five small, separate gardens representing different world cultures.

For starters, you are welcomed by the French garden's multitiered waterfall at the gate's entrance. And when you especially seek a respite, you should head for the walled Mission Courtyard or the Japanese garden's quiet pagoda in the upper northeast corner. Or relax in the English rose garden or Italian garden with a grapevine trellis. Beautiful as this is, it's not the kind of place that encourages spinning around in delight, Julie Andrews–style, on the green grass. Picnics are restricted to a cordoned-off area of tables, and visitors are asked to stick to the manicured pathways. It is, however, a welcoming public space in a community known mainly for its office parks and gated country-club developments.

↝ essentials

▤ 2001 Thousand Oaks Boulevard, Thousand Oaks, CA 91362

📞 (805) 557-1135 🌐 gardensoftheworld.info $ Free

🕐 Tuesday–Sunday, 9 a.m.–5 p.m.

🚌 Thousand Oaks Transit Route 3 or 4

peaceful place 38

GETTY CENTER AT NIGHT
Brentwood (MAP 3)

CATEGORY ↙: museums & galleries ✪ ✪

*B*y day, the museum that Angelenos affectionately call The Getty is one of Southern California's busiest tourist attractions. Vans shuttle thousands of folks up the long driveway to admire the stunning art collection, gardens, and priceless city-to-ocean views. By night, soft, romantic lighting, angular shadows, and the distant echoes of fewer heels on the expansive travertine marble floors trans- form the experience. It's open late (past 5:30, that is) only on Saturdays now, and, during the prime summer months, linger- ing sunset-watchers and a popu- lar outdoor concert series can make it seem as bustling as it is when the sun's out. You can avoid the masses by visiting after 5 p.m. during the post-holiday winter months, before Daylight Saving Time kicks in and spring break begins.

Have an early dinner at the estimable restaurant, where no

Seek out the Getty cafe's terrace at sunset.

table is bad; then stroll the emptying galleries and revel in having such a remarkable piece of Los Angeles to yourself. If you happen to show up after 5 p.m. during the busier summer months, here are the two places to seek out: the Lower Terrace Sculpture Garden (to the south of the Research Institute building)—where whimsical pieces such as *The Jousters* and *Three Squares Gyratory* reflect the sun as it seemingly disappears into the Pacific—and the terrace off the self-service cafe below the restaurant. The cafe closes in the late afternoon, but its outdoor tables remain open, and it's an especially peaceful spot to find yourself as the sun is setting—with a journal, a pleasant companion, or a glass of wine purchased from a nearby kiosk.

ᴗ᷅ essentials

⌨ 1200 Getty Center Drive, Los Angeles, CA 90049

☎ (310) 440-7300 🌐 getty.edu

$ Museum admission free; $15 parking (free after 5 p.m.)

🕐 Tuesday–Friday, 10 a.m.–5:30 p.m.; Saturday, 10 a.m.–9 p.m.;
 Sunday, 10 a.m.–5:30 p.m. Restaurant: Saturday, 5 p.m.–9 p.m.

🚌 Metro Bus Rapid Line 761

Soft lighting and angular shadows transform the Getty after dark.

peaceful place 39

GRAND HOPE PARK

Downtown Los Angeles (MAP 1)

CATEGORY ⌣ parks & gardens ✪ ✪

*W*hen Grand Hope Park opened in 1992, it was the first new major park in downtown L.A. since 1870. It was here long before all the loft-dwelling residents showed up, before the massive Ralphs grocery store opened across the street, and before TV's *Project Runway* started filming next door at the Fashion Institute of Design and Merchandising (FIDM). Run by a local nonprofit, its 2.5 acres are meticulously maintained and include meandering walkways, plenty of benches, a large patch of

Skyscrapers and palm trees frame Grand Hope Park.

grass, a playground, and two fountains. Don't be surprised if you see couples kissing on the lawn or holding hands beneath one of the bougainvillea-draped trellises. Framed by skyscrapers, it is a near-perfect city park in a perfect location, within walking distance of the Los Angeles Convention Center, concert and sports venues (such as Staples Center and Nokia Theatre), and a central subway station.

My favorite time to visit is Saturday morning, when the office workers and FIDM students who use the park are replaced by a mix of families, couples of all ages, and loft residents getting into motion to start the weekend with some sunshine and a cup of joe (several coffee outlets are nearby). It's always an additional treat to browse the ever-changing clothes and fabric inventory of the FIDM Scholarship Store (919 South Grand Avenue) or the Annette Green Perfume Museum on the second floor of the school. The one common gripe about this park is that dogs aren't allowed, even on a leash. But for some, that enhances the peaceful ambience here.

essentials

Hope Street at West Ninth Street, Los Angeles, CA 90015

FIDM Scholarship Store: (213) 624-1200

fidm.edu

Free

Daily, 6 a.m.–8 p.m. (summer); 7 a.m.–6 p.m. (winter)

Metro Rail Red Line to Seventh Street/Metro Center; DASH Route C

peaceful place 40

GREYSTONE MANSION
Beverly Hills (MAP 3)

CATEGORY ↝ historic sites ✪ ✪

*T*here are better views and quieter benches to be found in Los Angeles, but it's hard to beat the eerie beauty of this Gothic English estate just off Sunset Boulevard. It once belonged to the oil-rich Doheny family and was the site of a famous murder-suicide in 1929. Now it's a public park run by the city of Beverly Hills with an English garden, fountains, and multiple terraces with views that stretch to Santa Monica

Enjoy fountains and gorgeous views while strolling the grounds of Greystone Mansion.

and the ocean on a clear day. Wander a bit and you will discover that tasteful landscaping with dirt and sod has given the swimming pool new life as an inviting expanse of grass. You'll also pass a bathhouse and koi pond along brick walkways framed by rows of lavender. The mansion is a popular spot for film shoots: *Ghostbusters, Spiderman,* and *The Big Lebowski* count among the many movies with scenes set here. Ditto for wedding photos. But the grounds are large enough that it is easy to find a serene spot no matter what's going on. The mansion itself is open only for special occasions (such as chamber-music concerts and political fundraisers), but window peeking is OK.

⌣ essentials

✉	905 Loma Vista Drive, Beverly Hills, CA 90210
☎	(310) 285-6830
🌐	greystonemansion.org
$	Free
🕐	Daily, 10 a.m.–5 p.m. (Pacific Standard Time); 10 a.m.–6 p.m. (Daylight Saving Time); closed Thanksgiving and Christmas
🚌	Metro Bus Local Line 2

peaceful place 41

GRUB

Hollywood (MAP 2)

CATEGORY ↝ quiet tables ✪ ✪

*I*f I worked in one of the film-production facilities that dominate this industrial swath of Hollywood, I would try to eat lunch at Grub every day. A magazine, a corner outside table, and the After School Special (grilled cheese on sourdough, served with a cup of tomato soup) are all you need to carry you through the rest of the day. Hidden by a high trellis bloom-full of seasonal morning glories, the restaurant's small patio is marked by homey touches such as potted plants, mismatched umbrellas, and

Grub's cozy patio

flea-market antiques. It sort of feels as if you're eating in a friend's back garden. The inside dining room, in a converted house on a block of pretty bungalows, is appealing, too, but it's the patio that keeps me coming back here. In the evening, strings of white lights (and a limited selection of wine and beer) help make it a popular date-night destination for neighborhood couples. But they are in their own world and won't disturb your reverie. You can always snuggle up with a homemade cereal bar or any other comfort food item prepared with a grown-up touch here. Peacefulness tip: The weekend brunch is popular, so stick to a weekday lunch or dinner to avoid waiting with a crowd.

essentials

911 Seward Street, Los Angeles, CA 90038

(323) 461-3663

grub-la.com

Varies per menu selection; lunch, $9–$16

Monday–Thursday, 11 a.m.–9 p.m.; Friday, 11 a.m.–10 p.m.;
Saturday, 9 a.m.–3 p.m. and 5 p.m.–10 p.m.; Sunday, 9 a.m.–3 p.m. and 5 p.m.–9 p.m.

Metro Bus Local Line 10

peaceful place 42

GUM TREE

Hermosa Beach (MAP 5)

CATEGORY ⌣ shops & services ✪ ✪ ✪

*G*um Tree is the kind of place that makes you want to unpack your suitcase and move in immediately. Housed in a Craftsman bungalow a block from the Hermosa Beach Pier, it's a stylish yet cheerful shop, cozily divided into three main areas: a living room with pillow-lined sofas that overlook Pier Avenue, a dining room stocked with sand-dollar napkin rings and hand-painted platters, and a bed-and-bath section featuring French hand soaps and designer pajamas. A baby room in the back is

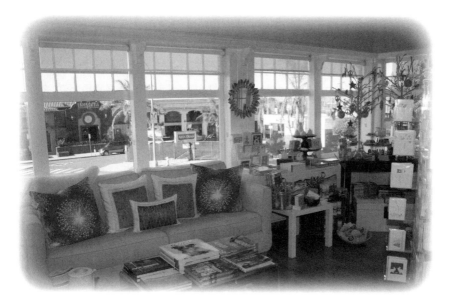

Gum Tree's living room encourages browsing.

so whimsical and welcoming that you almost expect a child to pop out of the organic cotton crib sheets. Sounds of Bob Dylan might drift from the stereo, or salesclerks might engage in a quiet conversation about gift-wrap preferences; customers can sashay from room to room as if they own the place.

A separate door on the left side leads to a full-service cafe that opens at 7 a.m. and specializes in organic, farmers market–inspired dishes such as roasted beet salad and Greek yogurt with house-made granola and wild honey. Australia-born owner (and chef) Will Ford is usually on hand, while his wife, Lori, runs the boutique. This is a family-friendly neighborhood hub at its sophisticated best, yet it still manages to make strangers feel welcome and comfortable.

essentials

	238 Pier Avenue, Hermosa Beach, CA 90254
	(310) 376-8744
	gumtreela.com
$	Prices range from $3 hand soaps to $800 designer necklaces
	Tuesday–Saturday, 10 a.m.–6 p.m.; Sunday, 10 a.m.–5 p.m.; closed Mondays
	Metro Bus Local Line 130; Commuter Express 438

peaceful place 43

HEISLER PARK

Laguna Beach (FARTHER AFIELD: MAP 9)

CATEGORY ✒: day trips & overnights ✪

*Y*ou can't exactly call this park hidden, as it is easily one of Laguna Beach's most popular gathering places. What's remarkable is how it manages to stay tranquil and lovely despite the wide mix of people who use it daily. When a group of architects, environmental designers, and urban planners set about naming the world's best parks, they ranked Heisler in the top 24, alongside New York's Central Park and Paris's Luxembourg Gardens, singling it out for its variety of activities and easy access. This 2-mile greenway

Enjoying ocean views and sunshine at Heisler Park

that runs along the bluffs of the Laguna coastline is arguably the prettiest stretch of coast-line in Southern California.

Lawn-bowling tournaments, sculptures, picnic tables, and soaring pelicans capture your attention when you're not mesmerized by the ocean views. Several long stairways lead down to charming coves and to cozy beaches (which can be crowded on summer weekends). Sunsets don't get much better than this: The sky turns multiple shades of pastels against a foreground of waves and palm tree silhouettes. It's the perfect way to end a day trip to Laguna Beach—or begin an evening if you've come for an overnight.

✎ essentials

✉	Cliff Street at Myrtle Street, Laguna Beach, CA 92651
☎	N/A
🌐	lagunabeachinfo.org
$	Free
🕐	Daily
🚌	Laguna Beach Transit Gray Line to North Laguna

peaceful place 44

HIDDEN TREASURES

Topanga Canyon (MAP 6)

CATEGORY ⌣ shops & services ✪ ✪

*T*his rambling old house is as much a microcosm of Topanga Canyon as it is a vintage clothing store. Walking through the front door is like entering another world or era, one that was smitten with pirates, Medusa heads, and canary-yellow feather

boas. So leave your judgment at home, strap on your sense of play, and have a good time. Barry Manilow or Styx might be playing on the stereo. Museum-like artifacts lure you to stop and gawk. (Looking for an antique deep-sea diver suit? Need a beer stein from 1900?) Aside from such items, the many rooms display such diverse merchandise as 1920s dresses, leather jackets, silk scarves, and perhaps the best tchotchke selection in the city. Still, the place rarely feels cramped, as some vintage stores do. Owner Darrell Hazen enlisted a feng shui specialist to help design the arrangements so that each room flows easily from

Deep-sea diver display

one to the next. When it does get a bit crowded, with stock and people—the days lead-ing up to Halloween, for example—I like to head outside to the patio, where grapevines cover the roof trellis, and a tankard-toting mermaid hovers over a Zen fountain and a few comfortably worn chairs.

↩ essentials

☐ 154 South Topanga Canyon Boulevard, Topanga Canyon, CA 90290

✆ (310) 455-2998 🌐 N/A

$ Prices range from $2 scarves to $60 leather jackets

🕐 Daily, 10:30 a.m.–6:30 p.m. 🚌 N/A

The patio at Hidden Treasures provides a respite from shopping.

peaceful place 45

H.M.S. BOUNTY

Koreatown (MAP 1)

CATEGORY ⌣ urban surprises ✪ ✪

*S*pending an hour or two in this time warp of a bar is like reading a Raymond Chandler novel in one sitting. The ghosts of such wide-ranging personalities as statesman Winston Churchill, newspaper mogul William Randolph Hearst, actor Jack Webb, and other luminaries haunt its red leather booths, while real-life characters converge around the wood-paneled bar to recall the days when they wrote songs for Aretha Franklin or flew B-17 bombers during World War II. Be prepared to adjust your eyes as soon as you push through the creaky foyer doors because it's darker than a bat cave in here.

The restaurant serves reasonably priced steak and potatoes fare, but the ambience is the star attraction. I like to head to the nook just beyond the bar near the cash register (which may be older than some of the patrons). That way, you're privy

H.M.S. Bounty's entrance on Wilshire Boulevard

to the amusing barfly conversations, but far enough away to have a quiet chat with your companions or sip your $4 gin and tonic undisturbed. On the way out, walk through the Art Deco lobby of the Gaylord, a 1950s-era apartment building, and tip your hat to the memory of the razed Ambassador Hotel, which stood across the street. (It was the site of nine Academy Awards ceremonies, and where Robert F. Kennedy was assassinated.)

essentials

3357 Wilshire Boulevard, Los Angeles, CA 90010

(213) 385-7275

thehmsbounty.com

Menu prices range from $7 for a sandwich to $18 for surf and turf

Sunday–Thursday, 11 a.m.–1 a.m.; Friday–Saturday, 11 a.m.–2 a.m.

Metro Rail Red Line to Vermont/Wilshire

peaceful place 46

HOLLYWOOD BOWL WEEKDAY REHEARSALS
Hollywood (MAP 2)

CATEGORY ⌣ urban surprises ✪ ✪ ✪

*A*peaceful place? Yes, I know that one of the most romantic—but not tranquil—venues on a summer evening in L.A. is on a bench under the stars at a Hollywood Bowl concert. Even romance meets risk, however, when the place is sold out (in which case things get a little too close for comfort unless you're the size of Sarah Jessica Parker). Or you end up sitting in front of a celebratory office group who are getting merry off a jug of merlot and wolf-whistling after every concerto. For an always

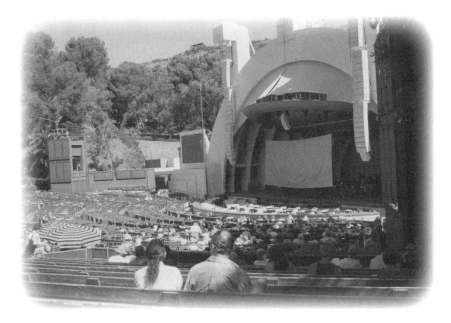

There's always elbow room at a Hollywood Bowl rehearsal.

quiet (though quite different) experience at the Bowl, sample one of the free weekday summer rehearsals by the L.A. Philharmonic. The first-tier Garden box seats are often reserved for Friends of the Philharmonic, but walk-ins have access to the Terrace box seats (which go for $84 in the evening) and section D, which offers some shade in mid-morning. The musicians may stop mid-piece and be partially blocked from audience view by shade curtains, but you will still get to experience top-shelf music at a historic venue under near-perfect skies with fewer than 100 other people.

I was a new transplant from the East Coast when I caught my first rehearsal in the late 1990s, and then returned years later as a new mother with a suddenly flexible morning schedule. It never loses its only-in-L.A. charm or the giddy feeling that you're in on a very cool secret while the rest of the city is working or stuck in traffic. Tip: It's always a good idea to call the Bowl box office early in the week; sometimes the L.A. Phil schedule changes or a Friday rehearsal is added.

essentials

✉ 2301 North Highland Avenue, Los Angeles, CA 90068

☏ (323) 850-2000

🌐 hollywoodbowl.com

$ Free

🕐 Tuesdays and Thursdays (and some Fridays) during July and August, approximately 9 a.m.–noon

�car Metro Rail Red Line to Hollywood/Highland

peaceful place 47

HOLLYWOOD PENSIONE

Hollywood (MAP 2)

CATEGORY ⌣ day trips & overnights ✪ ✪ ✪

*W*hether you and your partner want an escape to pretend that you are L.A. tourists, or you just need an overnight respite—or you really are just visiting the area—you'll appreciate the charm and quality of this small Craftsman-style inn. The hosts have gone out of their way to create a Zen-like cocoon in the middle of a dense stretch of East Hollywood. They outfitted each of the three guest rooms (all on the second floor) with luxury organic bed linens, reclaimed teak furniture, air purifiers, eco-friendly bath products, and an uncluttered feeling of absolute tranquility. A common lounge offers magazines and a leather sofa for relaxing, and the kitchen is stocked with French press coffeemakers, teapots, spices, and individual mini refrigerators. Breakfast is delivered on Japanese-style trays each morning, or you may choose to have it on the small balcony overlooking a backyard grapefruit tree and sitting area. Complimentary bottles of organic wine and chocolate truffles await your arrival, and Pilates classes are available during your visit. The Pensione specializes in long-term stays for entertainment-industry folks, who love its central Hollywood location, but two-night bookings are also available. The inn sits within walking distance of a parking-challenged but delightful commercial block of Franklin Avenue, so once you are completely calm and restored, you can shop or dine to your heart's content. *Note:* At press time, plans were in the works to add a large guest suite on the inn's first floor.

↩ essentials

☰ 1845 North Wilton Place, Los Angeles, CA 90028

✆ (323) 369-2411

🌐 hollywoodpensione.com

$ Rates start at $165 daily, $875 weekly

🕐 Open year-round

🚌 Metro Rail Red Line to Hollywood/Western; Metro Bus Local Line 2

peaceful place 48

HUNTINGTON LIBRARY, ART COLLECTIONS, AND BOTANICAL GARDENS

San Marino (MAP 8)

CATEGORY ↝ parks & gardens ✪ ✪ ✪

The former estate of railroad baron Henry Huntington is one of Southern California's most fabulous and well-known attractions, but it has a peaceful pocket for you, which I will get to in a moment. The Huntington's greatness is no secret, and most days you will find yourself elbow to elbow with other like-minded enthusiasts who are also enjoying its manicured paths and galleries. Sprawling across 200 acres just

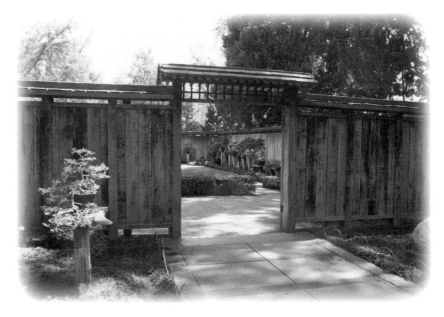

Escape to the bonsai court on especially busy days at the Huntington.

south of the Pasadena border, the library site boasts elaborate gardens, one of the most comprehensive collections of 18th- and 19th-century British and French art, and a rare book collection that includes Geoffrey Chaucer's *Canterbury Tales.*

On especially busy days (weekends and the first Thursday of the month, when admission is free), the bonsai court in the Japanese garden offers a quiet and shady respite. Located on the far western side of the property and framed by a walled courtyard and groves of bamboo, the court features miniature trees pruned to represent ancient tree forms and natural, elegant lines. The area is rarely crowded, save for a discreet security guard. The court itself has no seats, but if you exit from the rear, you will find a couple of small stone benches under a large ginkgo biloba tree. Nearby is a display of California jade "viewing stones"—stones found in nature that represent mountains, streams, and animals. On the other side of the court (closer to the traditional Japanese house) is a rock and sand garden fronted by a handful of benches, another pleasant place for quiet contemplation.

⌣ essentials

1151 Oxford Road, San Marino, CA 91108

(626) 405-2100 huntington.org

$ Saturday–Sunday and Monday holidays: $20 for adults, $15 for seniors, $10 for students ages 12–18, $6 for children ages 5–11, and free for children under age 5; Tuesday–Friday: $15 for adults, $12 for seniors, $10 for students ages 12–18, $6 for children ages 5–11, and free for children under age 5; free for everyone on the first Thursday of each month (reservations required)

Monday and Wednesday–Friday: noon–4:30 p.m.; Saturday–Sunday: 10:30 a.m.–4:30 p.m.; closed Tuesdays. From Memorial Day to Labor Day, Wednesday–Monday: 10:30 a.m.–4:30 p.m.

Pasadena ARTS Route 10 or 60

peaceful place 49

INN AT PLAYA DEL REY

Playa del Rey (MAP 4)

CATEGORY ᨓ day trips & overnights ✪ ✪ ✪

he L.A. metropolitan area is so vast that sometimes it's fun, even necessary, for residents to play tourist for a weekend and spend a night or two at a local hotel. The gray-shingled Inn at Playa del Rey is ideal for such a getaway. (Five minutes from LAX, it's also perfect for travelers looking for a one-night stopover that's a little more personal than the airport's offerings.) The 22-room Cape Cod–style bed-and-breakfast backs up to the Ballona Wetlands, Los Angeles's largest remaining bird-friendly stretch of saltwater marsh and grassy fields. If you're lucky enough to get one of the nine rooms that face the wetlands (well worth the extra dollars), the wetlands are yours to enjoy for your entire stay. Beyond the Ballona Wetlands, you can also see sailboats floating through the Marina del Rey channel, the distant outline of the Santa Monica Mountains, and the downtown Los Angeles skyline.

View of L.A.'s largest remaining wetlands

I can't emphasize enough the restorative powers this view had on me and my husband when we arrived for a weekend stay after a stressful stop-and-go drive on the San Diego freeway. We sat on the balcony for a long time, gulping the fresh ocean air and nibbling the fresh-baked cookies that greet every arriving guest. Guests without a marina view can still access it via the large balcony off the homey living and dining rooms, where breakfast and afternoon tea and lemonade are served daily. Other things that make this hotel a winner: a friendly, energetic staff; an easy three-block walk to the beach and South Bay bicycle path; and upscale touches that include luxury linens, whimsical beach decor, and Jacuzzi tubs (in some rooms).

essentials

435 Culver Boulevard, Playa del Rey, CA 90293

(310) 574-1920

innatplayadelrey.com

$ Marina view rooms start at about $200 per night

Open year-round

Metro Bus Local Line 115

peaceful place 50

INN OF THE SEVENTH RAY

Topanga Canyon (MAP 6)

CATEGORY ⌣ quiet tables ✪ ✪ ✪

While the Seventh Ray is a "hidden" restaurant well known in Southern California that has garnered hundreds of online reviews, its tranquil creek-side setting still takes your breath away. Or, better yet, it inspires you to do some deep, relaxing breathing. The leafy site once housed Topanga Canyon's first church, and offers seating both indoors and outdoors. But for maximum separation from the wide range of diners, you should request a table under a secluded gazebo, next to the gurgling central fountain, or overlooking the seasonal creek. The dinner and lunch menus feature salads, buffalo burgers, Alaskan halibut, grilled portobello mushrooms, free-range chicken, lamb chops, and a popular vegan seitan (mock) duck. All food is made on the premises and is, for the most part, organic, free range, and prepared without food colorings, preservatives, or

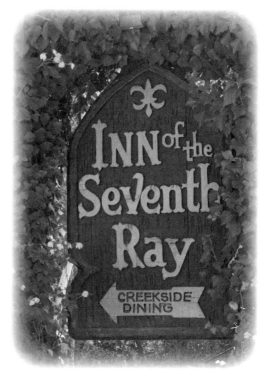

New Age dining in Topanga Canyon

refined sugar. I'm not a big fan of the small portions or the fact that they charge for valet parking here in the middle of the mountains, but I still think that this is a wonderfully unique spot to get away from it all for a few hours.

For the best experience, order a few appetizers and a selection from the very good wine list, and make sure to leave plenty of time for lingering. Make the day a total escape from urban L.A. by combining a visit to the Inn of the Seventh Ray with a show at Will Geer Theatricum Botanicum (page 204) or a shopping spree at Hidden Treasures (page 84), both of which are just down the road.

essentials

128 Old Topanga Canyon Road, Topanga Canyon, CA 90290

(310) 455-1311 innoftheseventhray.com $ Dinner entrees, $23–$41

Monday–Friday, 11:30 a.m.–3 p.m. and 5:30 p.m.–10 p.m.; Saturday, 10:30 a.m.–3 p.m. and 5:30 p.m.–10 p.m.; Sunday brunch, 9:30 a.m.–3 p.m. and dinner, 5:30 p.m.–10 p.m.

N/A

peaceful place 51

JACARANDA STREETS

West Los Angeles (MAP 3)

CATEGORY ⌣ urban surprises ✪ ✪

I still remember the first time that I drove down a street lined with jacaranda trees in full spring bloom. The endless purple canopy lifted my mood for the rest of the day and left me thrilled about the approach of summer. Native to the dry plains of Argentina and Brazil, the jacarandas were introduced to Southern California nearly a century ago and can be found everywhere from Westwood to the San Gabriel Valley. For most of the year, they sport unassuming green feathery leaves and tall, thin trunks. But in May and early June (and, to a lesser degree, in fall), they are more eye-catching (and, some complain, high-maintenance) than an Oscar-nominated actress walking the red carpet.

It's most fun to let the jacarandas catch you by surprise, as you turn down a street lined with them on your way to a dentist appointment or errand, but a few places are worth a special detour during peak bloom times. In Pasadena, Del Mar Boulevard between Lake Avenue and Arroyo Parkway is a broad, mile-long archway of purple flowers in the spring. Nearby in Sierra Madre, dozens of jacarandas line the residential streets south of Sierra Madre Boulevard near Memorial Park. Palm Drive north of Burton Drive in Beverly Hills transforms from a quiet street into a violet-hued wonderland every spring. One of the best places to sit and relax among the jacarandas is the Franklin D. Murphy Sculpture Garden at UCLA's Hammer Museum, where the trees complement dozens of abstract and figural sculptures and an inviting lawn. Stretch out along with the students cramming for finals in the sun, and enjoy the magical but fleeting sight of these purple blazers.

essentials

Neighborhoods are described at left; access to the Franklin D. Murphy Sculpture Garden (10899 Wilshire Boulevard, Los Angeles, CA 90024) is easy from the northeast side of the UCLA campus, off Hilgard Avenue

(310) 443-7000

hammer.ucla.edu

$7 parking

Daily

Big Blue Bus Lines 1, 2, 3, 8, or 12; Metro Bus Local 2 or 20

peaceful place 52

JACKALOPE
North Hollywood (MAP 7)

CATEGORY ⌇ shops & services ✪ ✪ ✪

*E*ven those who dislike shopping will have to admit that Jackalope is a very cool place to browse away an idle afternoon. Its indoor-outdoor space on a nonde-script San Fernando Valley block

practically begs you to linger, with complimentary water, low-pressure salesclerks, and row upon row of unique gurgling fountains. The only California branch of a small New Mexico–based chain of home and garden stores, it specializes in glazed pots and garden fountains, but also carries a swell selection of hand-painted furniture, Buddha statues, soy candles, Oaxacan wood carvings, and richly patterned pillows from India. Prices for most items are astoundingly reasonable. The complex is much bigger than it looks from the street, with patios giving way to rooms, giving way to more rooms. Still opposed to the idea

By the fireplace at Jackalope

of shopping? Park yourself on the leather couch in front of the huge stone fireplace and listen to the New Age music. No one will mind.

⌣ essentials

⌐≡ 10726 Burbank Boulevard, North Hollywood, CA 91601

☏ (818) 761-4022 🌐 jackalope.com

$ Prices range from $1 soy candles to $1,700 giant Buddha statues

🕐 Daily, 10 a.m.–6 p.m. �: Metro Rail Orange or Red Line to North Hollywood

Zen fountains for sale

peaceful place 53

JACK SMITH TRAIL

Los Angeles (MAP 1)

CATEGORY ⌣ enchanting walks ✪ ✪ ✪

*J*ack Smith was a beloved *Los Angeles Times* columnist who often wrote about the quirks and beauty of his hillside neighborhood, Mount Washington. After he died in 1996, his wife, Denny, and members of the community dedicated an urban trail in his honor. A contemplative tour of the best Mount Washington has to offer, it traces the cable car route that carried residents to and from their homes in the early 1900s.

The 3.2-mile trail begins at a tree-shrouded staircase, near West Avenue 43 and Marmion Way, the site of a former stop along the Pacific Electric trolley line. At the top of the staircase, follow Canyon Vista Road until it merges with Mount Washington Drive, then bear right and continue on to San Rafael Avenue. Here, you will find some of the area's stateliest homes, surrounded by large yards and formidable fences, as well as the former Mount Washington Hotel, a grand old building that attracted the likes of Charlie Chaplin and other movie stars, now the headquarters of a religious organization. Keep walking until you reach Moon Avenue, which is marked by hillsides blanketed with black walnut trees and seasonal wildflowers, then turn right and follow it to Crane Avenue, which leads you back down the hill to Marmion Way.

On clear days along this walk, you will be treated to dramatic views of Southern California's highest mountain peaks—San Antonio, San Gorgonio, and San Jacinto, as well as terrific vistas of the San Gabriel Mountains and the downtown skyline. You can just imagine Jack Smith leisurely walking the winding streets, soaking up the scenery as he crafted future columns about life in his adopted hometown.

Enjoy a picnic nearby on the grounds of the Southwest Museum of the American Indian (see page 171).

⌣ essentials

West Avenue 43 at Marmion Way, Los Angeles, CA 90050

N/A mtwashington.org

$ Free

Daily, 24 hours, but best visited during daylight hours

Metro Rail Gold Line to Southwest Museum

peaceful place 54

JAMES IRVINE JAPANESE GARDEN
Little Tokyo (MAP 1)

CATEGORY ⌣ parks & gardens ✪ ✪ ✪

his traditional Japanese garden, also known as *Seiryu-en*, or "garden of the clear stream," is an exquisite place to escape from the concrete buildings and bustle that make up Little Tokyo. Located within the boundaries of the Japanese American Cultural & Community Center, it is a hillside oasis of bonsai trees, azalea bushes, bamboo forest, and meandering paths. There are no benches, and food and drink are banned, so it is best used as a brief stop on a walking tour of Little Tokyo. Enter from a side gate or, if it is locked, via the ground floor of the cultural center. Weddings and other events take place here, so be sure to call first to confirm that it is open to the public on weekends.

Bonsai trees and waterfalls dot the James Irvine Garden.

⌣ essentials

⊟ Japanese American Cultural & Community Center, 244 South San Pedro Street,
Los Angeles, CA 90012

☏ (213) 628-2725

🌐 jaccc.org/garden.php

$ Free

🕐 Tuesday–Friday, 10 a.m.–5 p.m.; call for weekend schedule

🚌 Metro Rail Yellow Line to Little Tokyo; DASH Route A

peaceful place 55

JIN PATISSERIE
Venice (MAP 4)

CATEGORY ↝ quiet tables ✪ ✪

*T*he afternoon tea at Jin Patisserie isn't a formal affair. For one thing, you can order it before noon and into the early evening. And you can enjoy it in the front garden of this tiny pastry shop, where young and eager servers would never raise an eyebrow if you used the wrong spoon or dripped rose petal tea onto your slacks. Yet the beverage ensemble itself is as proper as it would be at any sophisticated tearoom: apricot-flecked scones, fine French tea (Theodor), and a selection of owner Kristy Choo's magnificently frothy cakes. The combination is irresistible to a Teva-wearing Californian like myself and, I surmise, to many of the T-shirted locals who frequent the place. Bamboo-shrouded walls dull the street noise, and the comfortable plastic chairs frame a small Zen fountain. Most days, fresh ocean air drifts in from a half mile away. I have brought my young

Enjoy tea and scones next to Jin Patisserie's Zen fountain.

children here on an uncrowded weekday and never felt rushed or uncomfortable (the menu even has a children's tea option). Located smack in the middle of the boutiques, restaurants, and bars of Venice's hippest street, Jin Patisserie has managed to create a delicious world apart from the surrounding activity.

↩ essentials

☰ 1202 Abbot Kinney Boulevard, Venice, CA 90291

☎ (310) 399-8801

🌐 jinpatisserie.com

$ Afternoon tea, $19; lunch, served all day, $13–$16

🕐 Tuesday–Sunday, 11 a.m.–6:30 p.m.

🚌 Big Blue Bus Line 2

peaceful place 56

KADAMPA MEDITATION CENTER
Silver Lake (MAP 1)

CATEGORY ⌣ spiritual enclaves ✪ ✪

*Y*es, the temple is right next door to an elementary school and within throwing distance of I-5 and Dodger Stadium, but this welcoming white-walled spiritual center manages to make you forget all about the urban noises that surround it. Every weekday at noon, the temple holds drop-in meditation classes for the public in a large, airy room anchored by a five-foot sculpture of Buddha. Novices are always welcome.

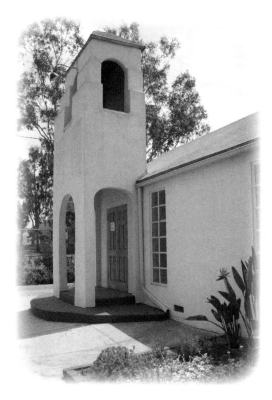

On Mondays, Wednesdays, and Fridays, the focus is on learning to meditate for relaxation and a clear mind. On Tuesdays and Thursdays, you can attend meditations to change your life, as the program describes them. Afterward, Monday through Friday, a delicious vegetarian lunch is served on the bougainvillea-covered patio for the bargain price of $5. You can buy texts

Exterior of Kadampa Meditation Center

on Kadampa Buddhism in the temple's small shop, or just sit and read in the bamboo-walled garden next to a soothing waterfall and pond. However long you stay, you will leave here with a calm mind and a desire to be a better person for at least the rest of the day, if not longer.

✌ essentials

📧 1492 Blake Avenue, Los Angeles, CA 90031

📞 (323) 223-0610

🌐 meditateinla.org

$ $8 per drop-in meditation class

🕐 Public hours: Monday–Friday, 10 a.m.–5 p.m.; Saturday, 11 a.m.–5 p.m.;
Sunday, 9:30 a.m.–1:30 p.m.

🚌 Metro Bus Local Line 96A

peaceful place 57

LACY PARK ROSE ARBOR
San Marino (MAP 8)

Category ↝ parks & gardens ✪ ✪

*L*acy Park is the kind of place that makes you forget all about earthquakes, freeway gridlock, and other unpleasant risks that come with being a Southern California resident. It is hands down the loveliest park I have ever visited. Tucked into a manicured San Marino neighborhood, the park has a lush, wide lawn framed by enormous shade trees, two paved trails, and a row of palms stretching to the sky. A memorial honors local war veterans, and a playground seems to attract every toddler playgroup in the San Gabriel Valley some days. So I suggest that you amble over to the rose arbor.

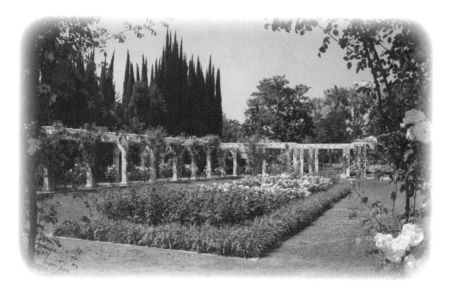

Lacy Park's rose arbor in full bloom

I visited Lacy Park several times before discovering this spot on the park's north side, but now I wouldn't think of missing out on its intoxicating mix of fragrances and colors anytime I'm in the area. I especially like to spend spring afternoons strolling through the arbor, and I follow my walk with a picnic or rest under a giant old tree overlooking the lawn. Tips: Park on St. Albans Road to be closest to the rose arbor entrance, and come on a weekday when nonresidents may enter for free.

✎ essentials

⊟ 1485 Virginia Road, San Marino, CA 91108

☎ (626) 300-0700 🌐 ci.san-marino.ca.us/lacy.htm

$ Free weekdays; $4 per person Saturday–Sunday

🕐 Monday–Friday, 6:30 a.m.–sunset; Saturday–Sunday, 8 a.m.–6 p.m.
 (Pacific Standard Time), 8 a.m.–8 p.m. (Daylight Saving Time)

🚌 Metro Bus Local Line 79

peaceful place 58

LAKE SHRINE TEMPLE
Pacific Palisades (MAP 6)

Category ↩ spiritual enclaves ✪ ✪

*A*mong my collection of peaceful places, this may be the most famous one in all of Los Angeles. Centrally located near the intersection of Sunset Boulevard and Pacific Coast Highway, it has its own visitor center and gift shop and seems to attract as many tour groups as it does individual followers of Paramahansa Yogananda, the religious leader who established it as a public shrine in 1950. That's no reason to avoid it, however. While the turreted temple is visible from as far away as the Pacific Coast Highway, mature trees surround the large lake and envelop the entire place in Zen-like calm.

Despite my awareness of all the Internet postings and photos of Lake Shrine, I wasn't prepared for the lake's beauty and complexity on my first visit. Families of ducks and koi fish the size of baby sharks are visible from the docks, and a path of cedar chips rings the water. Landmarks, such as a stone sarcophagus holding a portion of Mohandas Gandhi's ashes and a houseboat once used as a guesthouse, dot the path. A replica of a 16th-century Dutch windmill serves as a meditation center (pick up a schedule at the visitor center). Benches, some hidden and some facing the lake, are plentiful, and the Sunken Garden near the gift shop offers a private haven when the temple gets crowded.

Decades ago, this exquisite property had been written off as a useless swamp. But a 20th Century Fox executive had the grounds cleaned up. Then an oil-company executive purchased the property and sold it to the Self-Realization Fellowship Church after having a series of dreams about turning the lake into a place of worship. Yogananda and his followers opened it to the public in 1950. It has been a source of peace and escape for Angelenos ever since.

⌣ essentials

⌐≡˙⌐ 17190 Sunset Boulevard, Pacific Palisades, CA 90272

((310) 454-4114

🌐 lakeshrine.org

$ Free, but donations are welcome

🕐 Tuesday–Saturday, 9 a.m.–4:30 p.m.; Sunday, noon–4:30 p.m.

🚌 Metro Bus Local Line 2

peaceful place 59

LANDING GRILL & SUSHI BAR
Westlake Village (MAP 6)

Category ↙ urban surprises ✪ ✪

*M*y first impression of the Landing involved a woman dining alone at a small white-clothed table on a hillock overlooking the Westlake Village waterfront. Dressed in a tailored navy blue suit, she lifted her water goblet and smiled at me and my family as we walked along the nearby path. She gave off an envious aura of contentment as she resettled her unhurried gaze on the rippling water beyond us.

The tranquil setting is the main reason to visit this catch-all restaurant hidden behind a drab shopping center near U.S. 101 and the Ventura County border. Its outdoor patio overlooks a private lake that anchors the master-planned community of Westlake Village. Attractive homes and slow-moving boats flank the lovely lake, and rafts of ducks (no doubt emboldened by the aromas of the Landing's teriyaki chicken) often waddle over the hill. The Landing's patio offers a perfect venue for nonresidents to enjoy this peaceful scene, even into the evening, as heat lamps keep the area warm at night. The food at the Landing is on the predictable side: California rolls, Cobb salad, spareribs, and burgers. But it's a good place to take your mother for a lazy Sunday brunch or to linger over drinks and appetizers with friends at sunset—or to spend some time alone, like the woman in the navy blue suit. The waterfront view and feeling of seclusion are hard to match.

essentials

☑ 32123 Lindero Canyon Road, Westlake Village, CA 91361

☏ (818) 706-8887

🌐 thelandingwestlake.com

$ Lunch, $6.50–$13 for salads and sandwiches; entrees, $12–$18

🕐 Monday–Saturday, 11 a.m.–3 p.m. and 5 p.m.–9 p.m.; Sunday, 11 a.m.–9 p.m.

🚌 Metro Bus Local Line 161

peaceful place 60

LONG BEACH MUSEUM OF ART
Long Beach (MAP 5)

Category ↝ museums & galleries ✪ ✪

*T*his small art museum has a couple of features that make one want to linger for a pleasant hour or two, especially on a weekday. Head for the second-floor gallery, and plop down on the long bench in the middle of the room. Even on weekends, it may be all yours for gazing out the floor-to-ceiling windows that overlook the Pacific Ocean. When you tire of that (if possible), turn your attention to the works of contemporary California artists that line the room's three walls. (Alas, the wide balcony and its intoxicating sea breezes are off-limits.)

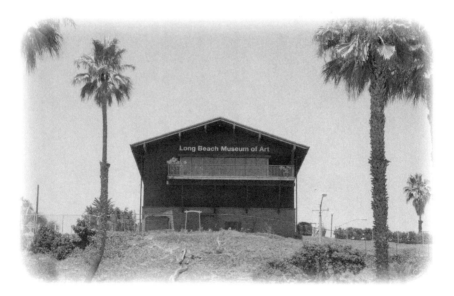

Long Beach Museum of Art's bluff-top campus

The second-best attraction: The museum's bluff-top campus includes a restored Craftsman bungalow with Claire's Restaurant—a cafe that also overlooks the ocean. The cafe's patio, which has tables that surround a huge metal and glass fountain sculpture, is a ladies-who-lunch scene on sunny days, while the wood-paneled dining room remains virtually empty. Seek out a cozy spot by the window in the room to the right of the entrance, order coffee or a decent (if overpriced) salad, and enjoy the same views as diners on the busier and noisier patio. On an overcast day, the dark wood and working fireplace make this as appealing as a ski lodge during a snowstorm. *Note:* Expect a wait during weekend brunch hours.

essentials

2300 East Ocean Boulevard, Long Beach, CA 90803

(562) 439-2119M lbma.org

$ $7 adults; free for children under age 12

Museum: Tuesday–Sunday, 11 a.m.–5 p.m.
Claire's Restaurant: Tuesday–Friday, 11 a.m.–3 p.m.;
Saturday–Sunday, 8 a.m.–3 p.m.

Long Beach Passport Bus A or D

peaceful place 61

LOS ANGELES COUNTY ARBORETUM & BOTANIC GARDEN

Arcadia (MAP 8)

Category ↝ parks & gardens ✪ ✪

*M*uch of this 127-acre botanic garden east of Pasadena can be described as restful and soothing. After all, it boasts a tropical greenhouse, towering palm trees, and plenty of wide-open green spaces. But my favorite contemplation spot is the Tallac Knoll, hidden high above the Mayberg Waterfall, where a handful of benches are scattered around a tropical pond flanked by gnarled oaks and clusters of daylilies. To

The view from Tallac Knoll

get there, climb the winding stone steps to the right of the waterfall. On a clear day you will be rewarded with a stunning view of the arboretum grounds backed by the San Gabriel Mountains. After soaking up the view, find a shaded bench and watch the birds and frogs frolic around the water-lily pond. Even on weekends, this area is rarely crowded, perhaps because of the steep climb required to reach it. If you get the urge to move, you can wander over to the huge collection of flowering magnolia trees.

⌣ essentials

301 North Baldwin Avenue, Arcadia, CA 91007

(626) 821-3222

arboretum.org

Free for members; $7 for adults; $5 for students and seniors; $2.50 for children ages 5–12

Daily, 9 a.m.–5 p.m.

Metro Bus Local Line 268; Foothill Transit 187

peaceful place 62

LOS ANGELES RIVER CENTER AND GARDENS
Cypress Park (MAP 1)

Category ↝ parks & gardens ✪ ✪

*L*ongtime Angelenos remember this beautiful hacienda as Lawry's California Center, a retail and dining showcase for the seasoned-salt empire's products. It closed in 1991, much to the devastation of those who spent many a summer night sipping margaritas and listening to live mariachi bands on its candlelit patios. While the restaurant and gift shops are long gone, the grounds are still exquisitely maintained by the Mountains Recreation and Conservation Authority and are open to the public most days. Just off the Arroyo Parkway north of downtown, it is an oasis of palm trees and ivy-covered walls amid the smog-check garages and gas stations that surround it. It's a bit like stepping into a novel about Old California (*Ramona* comes to mind): Murals cover the walls and gentle archways,

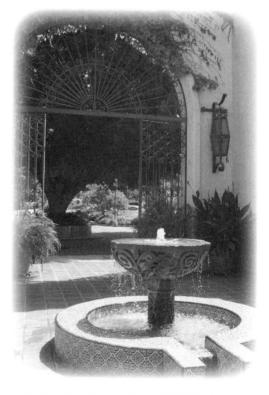

The L.A. River Center celebrates Old California.

and surprisingly lush tropical plants and flowing fountains drown out the steady traffic and nearby Amtrak train noise. Inside the California building, an informative display tells about the Los Angeles River, which is about a half block away. With a tire pump, water fountains, and repair station, the center is also a popular staging area for river-front bicyclists. Pick a spot among the multiple patios and lawn patches, and settle in for the morning with a book or a quiet chat with friends. If you think it's the perfect place for a marriage proposal, you won't be the first. Tip: Weddings and other group events are what keep this place in business, and you will find them going on most weekends and some weekdays. Be sure to call ahead before visiting to make sure it isn't closed for a private event.

essentials

570 West Avenue 26, Los Angeles, CA 90065

(323) 221-8900

lamountains.com

Free

Monday–Thursday, 7 a.m.–9 p.m.; Friday–Sunday, hours vary (call ahead to check)

Metro Rail Gold Line to Lincoln Avenue/Cypress Park; Metro Bus Local Line 68

peaceful place 63

MALAGA COVE
Palos Verdes (MAP 5)

Category ⌣ scenic vistas ✪ ✪ ✪

*L*ocals call it Rat Beach (for Right after Torrance), but there's nothing unseemly about this rocky crescent of sand at the southernmost point of Santa Monica Bay. It's hidden from sight at the end of a paved road across from Malaga Cove School, and parking is plentiful and free when school is out. To reach it, follow the paved road to the right of the gazebo until it ends at the water. A dirt path leads past a scenic stretch of rocks to the beach itself, which sits breathtakingly at the base of steep cliffs. Beach

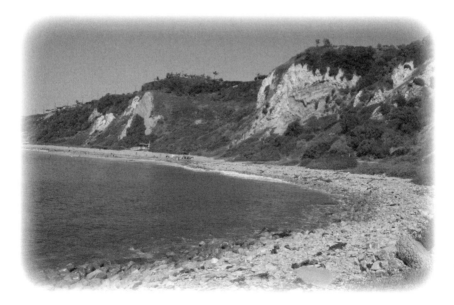

The rocky beach of Malaga Cove

time doesn't get much better than this: You can swim, sunbathe, surf, or just sit on a rock and enjoy the view of the entire Santa Monica Bay, all without parking hassles and fees. Another bonus: The water quality here consistently gets high grades from Heal the Bay's annual rating of California's beaches. On the way back to the parking lot, stop at Roessler gazebo for more ocean views and a peek at the Palos Verdes Beach & Athletic Club, which may be the South Bay's most scenic swim club.

essentials

▤	300 Paseo del Mar, Palos Verdes, CA 90274
✆	N/A
⊕	N/A
$	Free parking
⊕	Daily, sunrise–sunset
🚌	N/A

peaceful place 64

MAMA'S HOT TAMALES CAFÉ
MacArthur Park (MAP 1)

Category ⌣ quiet tables ✪ ✪

*O*nce quite a prestigious section of Los Angeles, MacArthur Park and its surroundings are more famous these days for booming stereo shops, crowded sidewalks, and street crime that still exists despite revitalization efforts. In the middle of it all sits a blue-awninged storefront with doors that give way to a welcoming burst of bright colors, mismatched chairs, and the scent of baking corn and cilantro. Ordering a *café con leche* or banana-leaf tamale here isn't just about having a meal, though it's a fine

An art and tamales haven near MacArthur Park

way to spend your lunch hour. Mama's is also a training ground for Latino street vendors (and others seeking hospitality jobs). They can practice making regional dishes in a professional kitchen—then go on to sell street food in carts or open their own small businesses.

For customers, the best tables in the main dining room overlook the park's spring-fed lake and palm trees. In this room, you're sure to be captivated by a realistic mural that dominates one wall and celebrates the cultivation of maize—the artwork portrays the Aztec goddess of corn in the midst of farmers working in fields that are lit by a bright yellow sun.

When I'm by myself, I like to seek out one of the tables in the back of the side room. That's where I can bask in the art collection, which is rotated from time to time, and do some serious people-watching. The friendly service can be slow, but that's all the more reason to linger if you have the time. Or, while you're waiting for your food to arrive at your table, slip over to the adjacent book nook, Libreria Hispanoamerica, for Central American literature, Pablo Neruda poetry, and other Spanish-language books.

essentials

☞ 2122 West Seventh Street, Los Angeles, CA 90057

☎ (213) 487-7474

🌐 mamashottamales.com

$ Lunch entrees, $4–$8

🕐 Daily, 11 a.m.–3:30 p.m.

🚇 Metro Rail Red Line to MacArthur Park/Westlake

peaceful place 65

MARGARET HERRICK LIBRARY, ACADEMY OF MOTION PICTURE ARTS AND SCIENCES

Beverly Hills (MAP 3)

Category ↙ reading rooms ✪ ✪ ✪

*Y*our name doesn't have to be Steven Spielberg or Clint Eastwood to use this Disneyland for cinephiles. Anyone with a valid photo ID is welcome to explore one of the world's most comprehensive movie research collections. Its holdings include 32,000 books, film scripts that date to 1910, millions of photographs and movie posters, and every issue ever published by *Daily Variety* and *Hollywood Reporter.* Among its special collections are costume sketches by Giorgio Armani for *American Gigolo* and 78 linear feet of papers devoted to the topic of Alfred Hitchcock and his work. If you're in a quick-skim *People* magazine mood, or don't have time to wait for the reference librarians to locate the more obscure materials, head to the computers and view an Oscar acceptance speech or

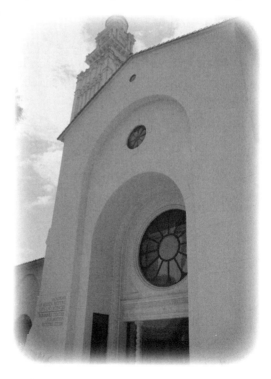

The library is inside the Fairbanks Center for Motion Picture Study.

look up what Gwyneth Paltrow wore on the red carpet in, say, 2002. Whatever your goals, the high-ceilinged, sunlit room makes for inspiring surroundings. Noise levels rarely rise above a whisper, and the large study tables are surrounded by vintage movie posters, original sheet music from *Chariots of Fire*, a kinetoscope, and Oscar statuettes (behind glass) from the 1950 and 1981 films, respectively, *Hello, Dolly!* and *All About Eve*.

⌣ essentials

✉ Fairbanks Center for Motion Picture Study, 333 South Cienega Boulevard, Beverly Hills, CA 90211

✆ (310) 247-3020

✆ oscars.org/library

$ Free

🕐 Monday, Thursday, and Friday, 10 a.m.–6 p.m.; Tuesday, 10 a.m.–8 p.m.

🚌 Metro Rapid Bus Line 728

peaceful place 66

MARINA DEL REY JETTY

Marina del Rey (MAP 4)

Category ⌣ outdoor habitats ✪ ✪ ✪

*T*his could be the nicest place to take a walk in all of L.A. When I first moved to Southern California, I lived close to this beach promenade and walked or ran it almost daily. My husband proposed to me at its far western tip, while the sound of ocean waves lapping against the rocks proved as romantic a backdrop as any candlelit dinner.

The jetty begins at the far southwestern corner of Marina del Rey and stretches out to the ocean. The first half mile of the walk (before you reach the actual jetty) is a paved path that is flanked by a wide white-sand beach to the north and the Marina del Rey

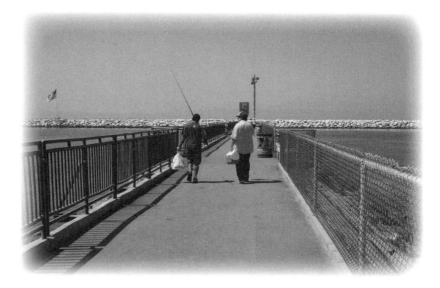

Fishermen and pedestrians favor Marina del Rey's jetty.

boat channel to the south. You can watch the sailboats, kayaks, tugboats, and cruisers drift in and out of the harbor, and drink in the coastal views that stretch as far as Malibu and Catalina Island. It's also a great place to watch planes taking off from LAX; the roar of the engines is distant enough not to be bothersome while also managing to inspire thoughts of escape. It's peaceful here any time of day or evening (though on weekends, foot and stroller traffic can get a bit heavy). But I like it best right around sunset, when many beach day-trippers have gone home, or early in the morning when the rolling fog swirls around the working fishermen casting from the rocks. Tip: Free parking can be found on the side streets off Via Marina, if you don't mind walking a few extra blocks.

⌣ essentials

At Via Marina and Pacific avenues, Marina del Rey, CA 90292

N/A

beaches.co.la.ca.us/bandh/marina/main.htm

Free (but two-hour parking 6 a.m.–10 p.m. is $1.25 an hour)

Accessible daily, year-round

Metro Bus Local Line 108, Rapid Line 3

peaceful place 67

MEDITATION MOUNT, INTERNATIONAL GARDEN OF PEACE

Ojai (FARTHER AFIELD: MAP 9)

Category ↺ day trips & overnights ✪ ✪ ✪

To digress for a moment, the entire Ojai Valley qualifies as an easy, idyllic escape from Los Angeles for a day or a weekend interlude. Framed by the Topa Topa Mountains, its Ojai Avenue main street hums with several spas, a large park, plenty of free parking, and a refreshing lack of national chains.

Meditation Mount on the outskirts of town gets my vote, however, for perhaps the most tranquil place within Ojai's boundaries. The site is a must-see for anyone who practices meditation or simply wants to quietly enjoy expansive views from one of the best perches in the area. At the end of a long, winding road at the east end of town, it is open to the public daily (though it's a good idea to call before you go to make sure no group events or weddings are scheduled for that day).

Stroll through the peace portal at Meditation Mount.

Park in the large lot and follow the signs for the International Garden of Peace, a half-mile-long path with benches, desert plants, and rocks carved with the principles of the property's owners: Right Human Relations, Goodwill, Group Endeavor, Unanimity, Spiritual Approach, and Essential Divinity. Seek out the bench at the path's end and take a few moments to drink in the stunning view of the entire Ojai Valley—a Shangri-la moment any time of day, but especially as the sun is setting over the mountain range. Near the entrance to the garden are a meditation chapel and a small lounge with a fireplace, herbal tea, and books on meditation and spirituality.

essentials

☰ 10340 Reeves Road, Ojai, CA 93023

✆ (805) 646-5508

🌐 meditation.com

$ Free; donations appreciated

🕐 Daily, 10 a.m.–sunset

🚌 Ventura Transit Line 16 runs to Ojai from the Ventura Amtrak station

peaceful place 68

MUSIC BOX AT FONDA—ROOFTOP SPEAKEASY
Hollywood (MAP 2)

Category ↙ urban surprises ★

*O*nly those attending a music or theater performance at the Music Box get access to this secret rooftop bar near Hollywood and Vine. Its exclusivity and erratic hours (it is open only before and during concerts) made me hesitate at first to include it in this book. But the striking Moroccan setting and romantic city-lights views make it well worth a visit for any serious L.A. bar hopper for whom such surroundings inspire a peaceful state of mind.

The bar's name gives nod to the theater's beginnings in the 1920s as a speakeasy and venue for Florenz Ziegfeld–style variety shows. Today, the stage at Music Box attracts independent singers and bands from Richard Thompson to Ben Folds Five, along with the occasional cabaret act. Before and between sets, the rooftop beckons. An open-air

Rooftop lounge at the Music Box

patio, it is anchored by a full-service bar and a long and cozy covered seating area with high ceilings, leather couches, heavy drapes, and exotic yellow and red decor. No food is served and the drinks can be pricey, but this has to be one of the best places in all of Los Angeles to spend your own quiet intermission.

essentials

⌨ 6126 Hollywood Boulevard, Hollywood, CA 90028

☎ (323) 464-0808

🌐 henryfondatheater.com

$ Beer, wine, and cocktails are $8 and up

🕐 Open before and during concerts; check Web site for current schedule

🚌 Metro Rail Red Line to Hollywood/Vine; Metro Bus Local Line 2

peaceful place 69

NORTON SIMON MUSEUM SCULPTURE GARDEN
Pasadena (MAP 8)

Category ↝ parks & gardens ✪ ✪

*A*fter enjoying the stunning collection of works by Edgar Degas, Pablo Picasso, Paul Cézanne, and other A-list artists in this fine small museum, head outside to the gardens to feel as if you've wandered into your own sun-dappled Impressionist painting. The sculpture garden, framing a large lily pond and studded by the abstract bronze torsos of Henry Moore, is nearly as big as the museum itself and deserves as much attention as the treasures inside. Anchored by two impressive trees, a cockspur coral and a Moreton Bay fig, it is also home to scads of lavender, giant bamboo, Chinese elms, and a grove of lemon-scented gum eucalyptus. Buy a drink from the cafe (and choose from premade sandwiches and salads, if you wish) and head to the back, where a couple of small tables await just beyond

Lily pond at the Norton Simon Museum Sculpture Garden

the waterfall. The garden abuts an entrance to the Glendale freeway, so street noise is unavoidable, but the raised view of the garden from this secluded spot is lovely. *Note:* The gardens close on rainy days and often remain closed for several days after heavy rains.

essentials

☰ 411 West Colorado Boulevard, Pasadena, CA 91105

☎ (626) 449-6840 🌐 nortonsimon.org

$ $8 for adults, $4 for seniors, and free for students and children age 17 and under

🕐 Monday and Wednesday–Sunday, noon–6 p.m.; Friday, noon–9 p.m.; closed Tuesdays

🚌 Metro Rail Gold Line to Memorial Park; Pasadena ARTS Route 10

An Impressionist painting come to life

peaceful place 70

OLD MILL (*EL MOLINO VIEJO*)
San Marino (MAP 8)

Category ✎ historic sites ✪ ✪ ✪

*I*f this landmark mill could talk, it would have tales from back in the day when Alta California belonged to Mexico. The granary, a handsome structure made of earthquake-defying adobe walls and ceiling rafters fashioned out of pine and sycamore, has soundly defied the odds of time. Now the site hosts rotating exhibits by California artists and showcases displays of vintage photographs and tools from the 1800s. Outside, the gardens include pear trees, walkways, a grapevine-covered gazebo, and a single splendid pomegranate tree anchoring one end of a large brick patio. Also showcased are a couple of millstones discovered in the 1800s by a local boy named George S. Patton, who grew up to become one of the country's most famous generals.

As the story goes, the mill operated only for about seven

The Old Mill's granary now hosts art exhibits.

years, then went dark for several decades before being purchased and renovated by Leslie Huntington Brehm, the widow of the son of railroad magnate Henry Huntington. She, in turn, willed it to the city of San Marino, which has been in charge of it since her death in 1962. Pair a trip here with a visit to the Lacy Park Rose Arbor (page 110), which is just down the road and once served as the main source of water for the mill.

⌣ essentials

⌷ 1120 Old Mill Road, San Marino, CA 91108

☏ (626) 449-5458

🌐 old-mill.org

$ Free

🕐 Tuesday–Sunday, 1 p.m.–4 p.m.

🚌 Metro Bus Local Line 79

peaceful place 71

ORCUTT RANCH
Canoga Park (MAP 7)

Category ⌣ outdoor habitats ✪ ✪

*O*ne of the first structures to greet visitors pulling into the parking lot of this San Fernando Valley property is a rusty hot-air windmill hovering over an orchard of trees bulging with fat grapefruits. It's the first sign that you have stepped into a bygone era of early California ranch life, one that involved plows, cultivators, herds of cattle, and hard, sun-baked labor. Ranch owner W. W. Orcutt was a geologist who later became a vice president of Union Oil Company, according to the City of Los Angeles Department of Recreation and Parks. He and his wife, Mary, used the place as a retreat from their mid-Wilshire home, building a Spanish Colonial–style ranch house that now serves mainly as a prep area for weekend weddings held in the gazebo and rose garden. The shaded and slightly overgrown grounds,

A 700-year-old oak tree sits on the property.

however, are open daily to anyone looking for a unique place to stroll or have lunch.

Following the nature paths beyond the main house is like going on a spontaneous treasure hunt marked by all sorts of surprises: a chair fashioned out of tree branches, a picnic grove, chipped stone pillars, footbridges, and a 700-year-old coast live oak tree. Orcutt Ranch welcomes you to a beautiful, unexpected stretch of green in a dusty, unremarkable part of the San Fernando Valley. Tip: The property opens its orange and grapefruit orchards one July weekend a year to bargain-hunting citrus pickers, and charges only $2 a grocery bag or $5 a box. You may bring your own fruit-picker pole or rent one.

⌣ essentials

▤ 23600 Roscoe Boulevard, Canoga Park, CA 91304

☎ (818) 883-6641 ⊕ laparks.org/dos/horticulture/orcuttranch.htm

$ Free ⏱ Daily, sunrise–sunset 🚌 N/A

Orcutt Ranch includes a Spanish-style adobe home.

peaceful place 72

PACIFIC ASIA MUSEUM
Pasadena (MAP 8)

Category ⌣ museums & galleries ✪ ✪ ✪

*O*n any given day, the courtyard of the Pacific Asia Museum is a special place to go for quiet reflection. Inspired by the classic gardens of China, the courtyard celebrates the harmony of architecture and nature. Plants and trees share space with decorative elements such as carved dragons, and provide a natural link to the museum's inside rooms and exhibits.

A particularly nice time to experience the courtyard is on Saturday mornings before the museum opens. That is when actor and Tai Chi master Chao-Li Chi leads his

Courtyard at the Pacific Asia Museum

students through the gentle stretches and gliding movements that make up the yang style of this ancient Chinese martial art. With its trickling waterfalls, carved stone lions, and bamboo and pine trees, the courtyard is as fitting a place to practice this graceful form of exercise as any lotus-specked park in China. As Chao-Li Chi has become older and less agile over three decades of Tai Chi classes, the loyal students have stepped up from time to time to help him lead long-form moves—or to encourage him to rest on a stone bench during breaks.

I find that observing these classes can be as inspiring and lovely as the surroundings. If you want to participate in the classes, you don't have to be an advanced Tai Chi practitioner; newcomers are welcome.

Note: The museum courtyard also hosts hatha yoga classes on Wednesday and Friday. Check the Web site for details.

essentials

46 North Los Robles Avenue, Pasadena, CA 91101

(626) 449-2742

pacificasiamuseum.org

Museum admission: $9; Tai Chi and yoga: $10 per class

Museum: Wednesday–Sunday, 10 a.m.–6 p.m.; Tai Chi classes: May–October: Saturday, 8 a.m.–9:30 a.m.; November–April: Saturday, 9 a.m.–10:30 a.m.

Pasadena ARTS Route 10 or 20

peaceful place 73

PACIFIC WHEEL

Santa Monica Pier (MAP 4)

Category ⌣ scenic vistas ✪ ✪

op on this beloved Ferris wheel, and let it swoosh you 130 feet to the best viewing deck on the Southern California coast. On clear days, the view from the top is a picture-postcard scene of the Pacific Ocean, the Hollywood Hills, Catalina Island, and the South Bay coastline from Marina del Rey to Malibu. Featured on *American Idol* and countless local news programs, the Pacific Wheel possibly has more TV and movie credits than the Hollywood sign. A shiny new solar-powered wheel replaced the

View of Santa Monica Beach from the top of Pacific Wheel

old wooden structure in 2009 and added 160,000 LED lights to keep the wheel ablaze in color at night and turn the ride into a romantic, dreamlike experience.

Whatever time of day you take a turn, it's a delightful five-minute escape from the crowds and traffic that always seem to swarm the pier and surrounding area. And you can always inflate those five minutes with more than one spin. Just purchase an unlimited-ride wristband (available online for $21), and schedule your visit for a slower time of year—mornings in the summer or most weekdays from September to May.

⌣ essentials

⌷ 380 Santa Monica Pier, Santa Monica, CA 90401

☏ (310) 260-8744

🌐 pacpark.com

$ $3 per person

🕐 Daily; check Web site for current times

🚌 Metro Bus Santa Monica Express 10; Big Blue Bus Lines 1 or 7

peaceful place 74

PAGODA BAR AT YAMASHIRO
Hollywood (MAP 2)

Category ⌣: quiet tables ✪

*T*ry, if you can, to ignore the mandatory valet parking, the high-priced cocktails, and the irreverent sushi menu with such offerings as Darth Vader and Crabby Pants. It's part of the package of visiting this storied Japanese restaurant in the Hollywood Hills. However egregious its faults, Yamashiro still boasts one of the best views of the city, and the 2009 reopening of its outdoor Pagoda Bar solidified its position as one of the best spots to get a pre- or post-dinner drink in all of Los Angeles.

Perched picturesquely next to a 600-year-old pagoda on a hilltop overlooking the city, it is more of an outdoor living room than a serious drinking establishment. Enjoy the view and your own quiet time with a friend, lover, or partner in this setting of comfortable couches, dim lighting, and a tiny bar offering wines and beers, muddled cocktails, and California rolls as nibbles. Stop by late on a weeknight, when the tour buses have left and the young and beautiful have been asleep for a couple of hours. The pool, which used to be a manmade pond that was home to rare black swans, shimmers in the moonlight, and the city unfolds in front of you in a haze of dancing searchlights and flashing billboards.

If you happen to show up when the bar is standing room only, head back to the main restaurant and request a courtyard table overlooking a flower-filled Japanese garden and meandering koi pond. There *are* ways to make this your own private place.

⌣: essentials

🖃	1999 Sycamore Avenue, Los Angeles, CA 90068 ✆ (323) 466-5125
🌐	thepagodabar.com
$	$8 valet parking; drinks $6–$14; appetizers and sushi $6–$18; dinner entrees $19–$39
🕐	Wednesday–Sunday, 6 p.m.–2 a.m. Metro Rail Red Line to Hollywood/Highland

peaceful place 75

PALEY CENTER FOR MEDIA
Beverly Hills (MAP 3)

Category ⌣ museums & galleries ✪ ✪ ✪

*A*nyone who thinks that his or her own living room is the most comfortable place to watch television may reconsider after visiting this sleek building near Rodeo Drive. Formerly called the Museum of Television and Radio, it houses a collec-

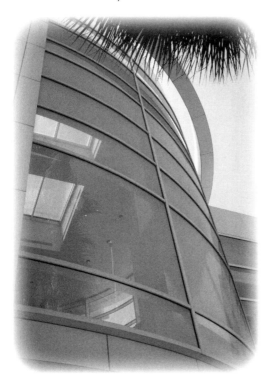

Exterior of the Paley Center for Media

tion of more than 140,000 TV and radio programs. You can view anything from the fight between Muhammad Ali and Joe Frazier to the final episode of *M*A*S*H*. Most shows are available (for watching here) to anyone who walks in and asks. Helpful staffers will lead you through the process (even suggesting programs to those overwhelmed by the huge database), then set you up at a computerized console outfitted with headphones and ergonomically correct chairs. Some consoles are designed for two or more people to share, and parents looking to introduce their children to shows such as *Captain Kangaroo* and

The Electric Company are welcome (with the caveat that the kids remain on their best behavior). In the rare instance that there is a wait for a console, the library is stocked with current copies of *Variety* and other entertainment magazines. Or you may explore the two galleries' media-related art exhibits. Whatever is going on outside (commercial shoots and busloads of tourists are typical), you will find an oasis of calm and refinement inside the doors of this gem of a museum.

⌣ essentials

▤	465 North Beverly Drive, Beverly Hills, CA 90210
✆	(310) 786-1091
🌐	paleycenter.org
$	Free; $10 suggested donation
🕐	Wednesday–Sunday, noon–5 p.m.
🚌	Metro Bus Rapid 704 or 4

peaceful place 76

PALIHOUSE'S HALL COURTYARD BRASSERIE

West Hollywood (MAP 3)

Category ⌣: quiet tables ✪ ✪

*L*os Angeles has no shortage of comfortable coffeehouses in which to hide away with a laptop or stack of scripts, but the Palihouse hotel's lobby brasserie, a couple of blocks from Sunset Strip, may be the most stylish of them all. The capacity is huge, with high ceilings and enough seating options to suit every mood: barstools, patio tables for two, long leather couches, wingback chairs, and marble banquettes. It's easy to find an inconspicuous nook and lose yourself in intimate conversation or a cup of high-voltage

Plenty of seating options at Palihouse's brasserie

espresso. Stacks of games (such as backgammon or dominoes), antique books by Marcel Proust and Charles-Pierre Baudelaire, and whimsical lighting and wall hangings keep the place from feeling too sterile or cavernous. The prices aren't aimed at struggling screenwriters (coffee will set you back $3), but portions are large (try the goat-cheese omelet for breakfast) and service affable.

In another sign that the place caters to every type of customer, its doors open at 8 a.m. and close as late as midnight on weekends. Stop by on a chilly winter evening for a cabernet or hot chocolate, and bask in the cozy glow of the faux fireplaces. The hotel specializes in long-term stays for guests, though overnight getaways are available.

⌣ essentials

🖹	8465 Holloway Drive, West Hollywood, CA 90069
✆	(323) 656-4020
🌐	thehallbrasserie.com
$	Breakfast, $8–$15; lunch, $12–$23; dinner, $19–$27
🕐	Tuesday–Friday, 8 a.m.–3 p.m. and 7 p.m. until close; Saturday and Sunday brunch, 11 a.m.–4 p.m. and dinner, 7 p.m. until close
🚌	Metro Bus Local Line 2, Rapid Line 704

peaceful place 77

PÂTISSERIE CHANTILLY

Lomita (MAP 5)

Category ↝ urban surprises ✪

*T*he overall experience at this tiny French-Japanese bakery transports you to another world. In fact, I predict that you will squint with surprise as you exit into the sunshine and asphalt of Lomita Boulevard. The small, bright room has a single counter with a glass case filled with owner Keiko Nojima's specialty pastries: green-tea chiffon cakes, passion fruit macaroons, and strawberry mousse tarts. Whether you place a large to-go order or ask for a single slice of cheesecake to eat at one of the small tables, you will be treated with the kind of individualized attention that has all but disappeared in the age of self-checkout grocery lines and big-box stores. The signature cream puffs are filled to order and presented to customers with the same seriousness with which a sommelier might offer a bottle of a fine Bordeaux. There's a thoughtful selection of coffee and tea, too. At first glance, Pâtisserie Chantilly might not seem like the quietest place around, but an hour spent surrounded by Nojima's delicate creations and genteel staff feels as refreshing as a visit to any fine museum or gallery.

↝ essentials

▤	2383 Lomita Boulevard, Lomita, CA 90717
✆	(310) 257-9454
⊕	patisseriechantilly.com
$	Individual pastries are $3–$5; whole cakes start at $26
☾	Monday, 11 a.m.–6:30 p.m.; Wednesday–Sunday, 11 a.m.–7:30 p.m.
⛍	Metro Bus Torrance Line 5

peaceful place 78

PETER STRAUSS RANCH
Agora Hills (MAP 6)

Category ↝ enchanting walks ✪ ✪ ✪

*O*ne of the great unsung picnic areas within the Santa Monica Mountains National Recreation Area can be found on the grounds of this woodsy ranch off Mulholland Highway. Once home to the Chumash people, the area has a colorful past that includes diverse stints: The property has been the weekend retreat of American racing legend Harry Miller, and in its amusement park days, it boasted of having the largest swimming pool in the West. Actor Peter Strauss bought the place when he was in the area filming the TV miniseries *Rich Man, Poor Man* in 1976. Thankfully for all of us, he fixed it up and sold it to the Santa Monica Mountains Conservancy in 1983. The ranch house remains intact, as do the ample front lawn and amphitheater. Still, the whole place has a bit of a melancholy, abandoned feel, as if the last residents had to leave suddenly but expected to return someday to resume a life of quiet leisure. A resident peacock often struts about, and a short, well-marked hiking trail leads you past all the now-empty ranch highlights. You'll note the horse stables, the aviary, the drained circular pool, and a huge patio off the main house. You can only imagine that it must have hosted some excellent summer barbecues. Bring a picnic lunch and enjoy it on one of the patio's picnic tables, or settle on the wide front lawn near the entrance. Even with its proximity to Mulholland Drive, the place provides a peaceful, mostly shady refuge to anyone who wanders through its gates. *Note:* The amphitheater hosts live folk and bluegrass concerts on Sunday afternoons during the summer.

↝ essentials

30000 Mulholland Highway, Agoura Hills, CA 91301

(805) 370-2301

nps.gov/samo

$ Free

Daily, sunrise–sunset; often closes after heavy rains due to flooding

N/A

peaceful place 79

POINT VICENTE INTERPRETIVE CENTER
BLUFFS TRAIL

Rancho Palos Verdes (MAP 5)

Category ↝ enchanting walks ✿ ✿ ✿

*T*he flat, paved trail that begins at Point Vicente Interpretive Center would count as a good running or walking trail even if it didn't come with one of the finest free ocean views around. Set high atop the coastal bluffs in one of L.A.'s most afflu-ent suburbs, it is nothing short of spectacular. Come here for uninhibited views of Point Vicente Lighthouse and the Pacific. There is no bad time or season here, though the sunsets deserve bonus raves. In winter, it's a whale watcher's dream—so much

View from the Point Vicente bluffs trail

so that the American Cetacean Society uses the patio near the trailhead to track the annual southern migration of gray whales. In early spring, purple and yellow wild-flowers blanket the bluffs and nearby fields. Despite its beauty, this mile-long path is rarely crowded—maybe because it's challenging to find much information about it. I stumbled upon it while taking the scenic route, along Palos Verdes Drive West, from LAX to Long Beach. I made a spontaneous stop at the interpretive center and came away with a better understanding of the development of the Palos Verdes Peninsula and real appreciation for its natural beauty.

✧ essentials

⌸ 31501 Palos Verdes Drive West, Rancho Palos Verdes, CA 90275

📞 (310) 377-5370

🌐 palosverdes.com/rpv/recreationparks/pointvicenteinterpretivecenter

$ Free

🕐 Grounds: Daily, sunrise–sunset; Center: Daily, 10 a.m.–5 p.m. (except some holidays)

🚌 N/A

peaceful place 80

PROUD BIRD

Los Angeles International Airport (MAP 5)

Category ✔ urban surprises ✪ ✪

*N*o, I am not crazy: You *can* escape clamor somewhere within the frenetic environment of LAX. My choice is the terrace at the Proud Bird, a classic restaurant next to Parking Lot B. You may think that the Bird looks like a tired banquet hall that has seen better days. Instead, you'll find a celebration of aviation, old-school dining, and gentlemanly waiters. But the real reason to come here for an adult time-out is the terrace.

Watch planes land from Proud Bird's patio.

Set your mind free as you take in primo views of the 747s coming in for a landing on the adjacent runway. The menu tends toward the safe steakhouse variety—prime rib, shrimp cocktail, Caesar salad. But food takes a passenger seat to the display of vintage and replica planes dating to World War II that fill the lawn just beyond the terrace. Do have a look inside, too, where black-and-white photos of flying aces and historical aviation scenes cover the paneled walls. The dining rooms can get loud during weekday lunch, when local business crowds dominate, but the less-formal terrace is always low-key, as long as you don't mind the roar of jets every six minutes. In some strange way, that can be soothing.

And if your flight is delayed, well, there's no question that this beats any food court. Or if LAX is your home destination and you know there's nothing in your fridge to cook, unwind here before you reenter your daily life.

essentials

11022 Aviation Boulevard, Los Angeles, CA 90045

(310) 670-3093

theproudbird.com

Lunch, $10–$14; appetizers, $5–$18; dinner, $15–$31

Monday–Friday, 11 a.m.–10 p.m.; Saturday, 11 a.m.–midnight; Sunday brunch, 9 a.m.–3 p.m. and dinner, 4 p.m.–10 p.m.

To get to the Proud Bird from the baggage claim area, just take the Airport Bus to Parking Lot B and walk west on West 111th Boulevard to the corner of Aviation Boulevard; by public transport, take the Metro Green Line to Aviation/LAX or Metro Express Line 439 to Aviation Boulevard and 111th Street

peaceful place 81

RICHARD J. RIORDAN CENTRAL LIBRARY
Downtown Los Angeles (MAP 1)
Category ↝ reading rooms ✪ ✪ ✪

*L*os Angeles's main library is one of the largest in the nation, and its grand rotunda, art galleries, and gift shop make it worth a visit for reasons other than for books or research. For readers seeking a hushed space to get lost in a good novel or a *New Yorker* article, one of the best perches in the building is in the Fiction and Literature Room's reading area on the fourth floor.

Tucked a respectable distance away from the information desk and around the corner from the Mystery section, it features a long row of comfortable leather chairs. Pick one and enjoy the bird's-eye view of the colorful chandeliers, 13-foot-tall lanterns, and four stories of elevators that make up the library's atrium. If all those cushy leather seats are taken, you can always hang out at one of the nearby tables and wait for someone to leave—or visit in the early evening (Monday through Thursday) when it tends to be less crowded.

↝ essentials

▤ 630 West Fifth Street, Los Angeles, CA 90071

☏ (213) 228-7000 ⊕ lapl.org $ Free

◔ Monday–Thursday, 10 a.m.–8 p.m.; Friday–Saturday, 10 a.m.–6 p.m.;
 Sunday, 1 p.m.–5 p.m.

🚌 Metro Rail Blue or Red Line to Seventh Street/Metro Center,
 or Red Line to Pershing Square

peaceful place 82

RUSTIC CANYON PARK
Pacific Palisades (MAP 4)
Category ↙ parks & gardens ✪ ✪

*T*he roads surrounding Rustic Canyon Park off Sunset Boulevard are narrow and meandering, punctuated at every corner by leafy trees and discreet gates. No signs point you in the park's direction, so don't leave home without a *Thomas Guide* or GPS system.

The huge trees of Rustic Canyon Park

When you pull into the parking lot, it can be confusing at first because all you will see is a Spanish-style recreation center and a gate surrounding a community pool. The park element of the complex sits in its own forested world at the bottom of a paved pathway off the parking lot. There you will see tennis and basketball courts and enough picnic tables to accommodate a large wedding. But my favorite spot for a respite is the playground with a couple of sprawling, low-to-the-ground sycamore and oak trees. They are great for safely stretching out on, Tom Sawyer—style. Despite

the park's hidden location, it does get crowds. It hosts a kids' camp on summer weekdays and is a popular weekend spot for birthdays and barbecues. So come early in the morning or late in the afternoon if you want to feel as if you're in an undiscovered wonderland. When the masses start showing up, it's time to head down Latimer Road or La Mesa Drive for a half-mile walk through Rustic Canyon, unquestionably one of L.A.'s most appealing neighborhoods. Then come back to the park for more downtime under those giant old trees.

⌣ essentials

	601 Latimer Road, Pacific Palisades, CA 90402	✆ (310) 454-5734
🌐	laparks.org/dos/parks/facility/rusticcynpk.htm	$ Free
🕐	Monday–Thursday, 9 a.m.–10 p.m.; Friday, 9 a.m.–7:30 p.m.; Saturday–Sunday, 9 a.m.–6 p.m.	
🚌	N/A	

A giant sycamore flanks the playground.

peaceful place 83

SANTA CRUZ ISLAND

Cavern Point, Ventura County (FARTHER AFIELD: MAP 9)

Category ⌣: day trips & overnights ✪ ✪

It takes about an hour and a half to get to Ventura Harbor from downtown Los Angeles. Then it's another hour by boat to Scorpion anchorage on Santa Cruz

The view from Cavern Point, Santa Cruz Island

Island. By the time you are reveling in the sweeping views from Cavern Point or paddling a kayak out to sea, most of the morning is gone. But it doesn't matter. A few hours on this remote island feels like a few days—glorious, trouble-free, back-to-nature time. The largest of five islands in the Channel Islands National Park, Santa Cruz is the most accessible, with daily boat trips from Ventura and Oxnard, and two campgrounds within easy walking distance of the pier. Kayaking is a popular way to spend time here, and several water-sports outfitters offer guided tours of the hauntingly beautiful sea caves that can be found on either side of the pier. You'll come within

reaching distance of pelicans, red and orange starfish, purple sea urchins, bright orange Garibaldi fish, and kelp so big that it seems biologically engineered. Inside the caves, all you are likely to hear is the sound of waves rippling and echoes of seals barking.

Back on the island, hiking options are many, but the best bang for your buck is Cavern Point, a moderate uphill walk past meadows to panoramic vistas that will make you think you've reached the ends of the earth. You are bound to find others up here also admiring the views (especially if you join the ranger-led hikes offered a few times a day), but it's fairly easy to stake out a spot, fixate on the ocean, and get lost in your own idyllic escape for as long as you want. Tip: Boats run to Santa Cruz year-round, but September and October often bring the best kayaking conditions (warm water, calm seas) and the fewest crowds.

Note for overnighters: If you're not the camping sort, consider spending the night just a few miles from the harbor, at Bella Maggiore Inn (67 South California Street, Ventura, CA 93001; [805] 652-0277; rates $90–$180 a night). You may get to know the resident ghost, Sylvia, who reportedly wanders the halls in a haze of rose-scented perfume. The tastefully furnished rooms (some with fireplaces and bay windows) and the in-house courtyard restaurant, Nona's, provide a welcome respite from the busy pedestrian traffic of Main Street.

⌣ essentials

▤	Boats depart from Ventura Harbor near the Island Packers office, 1691 Spinnaker Drive, Ventura, CA 93001
✆	(805) 642-1393 (for Island Packers transport service)
🌐	nps.gov/chis; islandpackers.com
$	$48 round-trip to Santa Cruz Island; $75 kayaking trips run by Island Packers
🕐	Year-round
🚌	Amtrak's Pacific Surfliner to Ventura

peaceful place 84

SELF-REALIZATION FELLOWSHIP TEMPLE

East Hollywood (MAP 2)

Category ↝ spiritual enclaves ✪ ✪ ✪

Peaceful landscaping at Self-Realization Fellowship Temple

*S*unset Boulevard just west of Vermont Avenue is a chaotic, 24/7 kind of place. Kaiser Permanente medical buildings line both sides of the street, a subway station brings a large amount of foot traffic to the area, and a bright blue Church of Scientology complex sprawls across an entire city block. In the middle of all this sits a small white temple surrounded by gated gardens that seems to have been airlifted in from the banks of the Ganges River. One of half a dozen Los Angeles–area spiritual centers founded by Paramahansa Yogananda, it opens its grounds and meditation rooms to the public every day.

Visitors may park for free in the small lot off Edgemont Street and wander at their leisure around the grounds. And there is much to wander around. The site includes a well-tended

lawn, flower beds, and a gazebo with stained glass windows and marble benches over-looking a lily pond. The gazebo's location across from a hospital and near a busy stretch of the 101 freeway makes it an ideal sanctuary for anyone coping with bad medical news or simply looking to postpone a bumper-to-bumper commute. Someday I will check out the free weekly hatha yoga and meditation classes the temple offers, but so far I have managed to get all the serenity and good feelings I need from those marble benches.

⌣ essentials

✉	4860 Sunset Boulevard, Los Angeles, CA 90027 ✆ (323) 661-8006
🌐	yogananda-srf.org/temples/hollywood $ Free
🕐	Grounds and book room: Tuesday–Saturday, 9 a.m.–4 p.m.; Sunday, 10:30 a.m.–1 p.m.; Meditation temple: Daily, 5:30 p.m.–7:30 p.m.
🚋	Metro Rail Red Line to Vermont/Sunset

A small lily pond sits outside the gazebo.

peaceful place 85

SERRA RETREAT

Malibu (MAP 6)

Category ↝ spiritual enclaves ✪ ✪ ✪

*S*ilence rules at this Franciscan monastery high in the Malibu hills. Serra specializes in overnight retreats for groups and individuals, but anyone can drive up its winding driveway on weekdays and enjoy the gardens and million-dollar ocean views. Named after Father Junipero Serra and embodying his motto, "Always move forward, never turn back," it is a priceless piece of real estate with a gated entryway off Pacific Coast Highway. (Neighbors include Mel Gibson and James Cameron.)

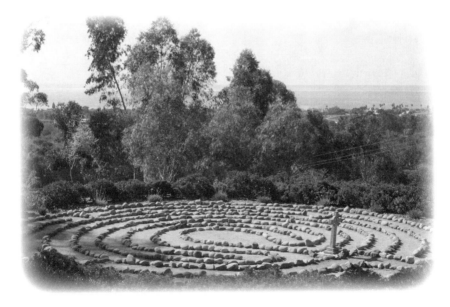

Serra Retreat's labyrinth overlooks the ocean.

The Spanish Mission–style buildings are off-limits to those not participating in a retreat, but there is plenty to see and do outside. Walk the stone-lined Santa Rosa labyrinth. Wander the paths flanked by pine trees and statues of St. Francis and the Stations of the Cross. Admire the Malibu-tile staircases and bougainvillea dusted by salt air. Finally, sit on a bench with 360-degree views of the mountains and sea, and, as the retreat's Web site urges in a biblical reference, "Come apart and rest awhile." *Note:* When there is availability, the retreat allows individuals to stay in its basic but comfortable rooms for $129 a night.

↩ essentials

✉	3401 Serra Road, Malibu, CA 90265
☎	(310) 456-6631
🌐	serraretreat.com
$	Free
⏱	Grounds: Monday–Friday, 9 a.m.–5 p.m.
🚌	Metro Bus Express Line 534

peaceful place 86

SKIRBALL CULTURAL CENTER
Brentwood (MAP 3)

Category ⤳ urban surprises ✪ ✪

*Y*ou can't round a corner in L.A. in July and August without bumping into a free outdoor concert. From San Pedro to the Santa Monica Pier, they are ubiquitous and vary wildly in music and crowd levels.

One of my favorite hassle-free spots to enjoy moonlit music is from the courtyard balcony of the Skirball Cultural Center, just off the 405 freeway near one of L.A.'s busiest corridors. The concerts, which are held most Thursdays in July and August, spotlight a variety of musical traditions each season, from klezmer (Jewish instrumental music) to Mardi Gras jazz. The temporary stage sits over the courtyard's large reflecting pool, which picks up the sun's rays as it sets over the Santa Monica Mountains. The purple-blue hues of jacaranda trees, strung with white lights,

Ringside concert seats at the Skirball

provide a festive backdrop. The soothing setting makes up for having to share this experience with other concertgoers.

For ringside seats with sights that encompass the performers and the sheltering hillside, head upstairs to the balcony that circles the courtyard. If all seats there are taken, you can always settle on a spot in the grassy area or lean against a wall and take it all in. If you want a guaranteed seat, try to arrive before the doors open at 7 p.m., and make peace with the fact that you'll have to line up with the other eager folks. Judging by all the early arrivals, these concerts are almost as popular with adults as the downstairs Noah's Ark exhibit is with preschoolers.

If you happen to miss the summer concerts, visit the Skirball's courtyard (official name: Mark Taper Foundation Courtyard) during the week. You'll find a cafe and a kiosk serving sandwiches and salads near the lobby, and you can enjoy a casual quiet lunch amid those beautiful jacaranda trees.

essentials

2701 North Sepulveda Boulevard, Los Angeles, CA 90049

(310) 440-4500

skirball.org

Concerts are free; $5 parking

Building and grounds: Tuesday–Friday, noon–5 p.m. (until 10 p.m. on concert nights); Saturday–Sunday, 10 a.m.–5 p.m.

Metro Bus Rapid Line 761 to Sepulveda Boulevard at Skirball Center Drive

peaceful place 87

SMALL WORLD BOOKS

Venice (MAP 4)

Category ↩ reading rooms ✪ ✪

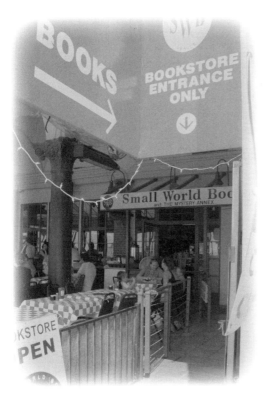

Venice Boardwalk's only bookshop

he Venice Boardwalk is one of the last places you would expect to find a very good independent bookstore (let alone a spot with a peacefulness rating). Yet here it is: Small World Books beckons you from its location right between the always-packed Sidewalk Café and a shop stuffed with T-shirts and cheap sunglasses, and just up the road from the grunting spectacle of Muscle Beach. As soon as you enter, the sound of boom boxes recedes, and you are surrounded by floor-to-ceiling stacks of fiction, poetry, biographies, and one of the best mystery selections in all of L.A.'s proverbial Raymond Chandleresque County. The employees show off their book sense in the multiple displays of handwritten staff recommendations. The latter includes anything from the latest Richard

Price novel to a children's guide to jazz. After spending an hour browsing in this hushed, laid-back haven, you'll be ready to once again brave the unrelenting circus and sunshine awaiting you right outside.

⌣ essentials

✉	1407 Ocean Front Drive, Venice, CA 90291
☎	(310) 399-2360
🌐	smallworldbooks.com
$	Free except for purchases
🕐	Daily, 10 a.m.–8 p.m.
🚌	Big Blue Bus Lines 1 or 2

peaceful place 88

SMOKE HOUSE

Burbank (MAP 7)

Category ⌣ quiet tables ✪

*L*os Angeles is thick with 1940s-style steakhouses, and entire Web sites and late-night conversations have been devoted to which ones are the best. But when it comes down to which one has the coziest bar lounge, my vote goes to the Smoke House in Burbank. It's big and dark, with wood paneling, red-leather banquettes, and deep swivel chairs that could swallow the actresses who occasionally stroll in from Warner Brothers Studios, across the street. (Plus, the Disney and NBC/Universal lots are close by.)

From some of the small tables, you can see the dining room where Jack Warner and Milton Berle and other entertainment VIPs congregated—probably to hammer out deals over steaks and cocktails. The bar can get rambunctious during weekday happy hours, but it's a very pleasant place to be on an early Saturday evening before the band begins its 8 p.m. set, especially if you like fine martinis and unhurried conversation. Add a serving of the legendary garlic-cheese bread and you will completely forget that you are in a not-so-picturesque nook of the San Fernando Valley.

⌣ essentials

▤ 4420 West Lakeside Drive, Burbank, CA 91505 ✆ (818) 845-3731

🌐 smokehouse1946.com

$ Appetizers, $5–$12; lunch entrees, $9–$15; dinner entrees, $14–$32

🕐 Monday–Thursday, 11:30 a.m.–10 p.m.; Friday–Saturday, 11:30 a.m.–midnight; Sunday, 10 a.m.–9 p.m.

🚌 Metro Bus Local Line 222

peaceful place 89

SOFI GREEK RESTAURANT

Mid-Wilshire, West Los Angeles (MAP 3)

Category ↝ quiet tables ✪ ✪

The bougainvillea-draped patio of this restaurant will make you feel as if you've stumbled onto the square of a real Greek village. Its location, at the end of a narrow alley off Third Street near The Grove shopping complex, has kept it hidden from walk-in crowds but made it a reliable romantic destination for those in the know.

There is an indoor dining room as well, but the best seats in the house are on the lush patio under the stars and strings of tiny lights. You can have a full Greek dinner with all the usual fixings (such as mousaka or chicken souvlaki), or just order a bottle of wine and feast on the *tsatziki* and warm pita bread that magically appears as soon as you sit down. Lilting guitar and piano music on weekends starts around 9 p.m. Despite its proximity to some of L.A.'s most popular restaurants (such as AOC and The Little Door), Sofi has outlasted many of its trendier neighbors and doesn't show any signs of disappearing. The restaurant is also open for lunch, but you would be missing out on its restorative powers if you didn't stop by on a warm summer evening.

↝ essentials

⌨ 8030¾ West Third Street, Los Angeles, CA 90048 ✆ (323) 651-0346

🌐 sofisrestaurant.com $ Appetizers, $8–$15; entrees, $18–$30

🕐 Sunday–Thursday, 11 a.m.–3:30 p.m. and 5:30 p.m.–10:30 p.m.;
 Friday–Saturday, 11 a.m.–3:30 p.m. and 5:30 p.m.–11 p.m.

🚌 Metro Bus Local Lines 14 or 16

peaceful place 90

SOUTHWEST MUSEUM OF THE AMERICAN INDIAN
Los Angeles (MAP 1)
Category ↝ scenic vistas ✪ ✪ ✪

*T*he legendary taco trucks of Highland Park offer some of the tastiest bargain lunches around. But once you've snagged your *taco al pastor* or *carnitas* plate, you are pretty much limited to wolfing down the tasty food while you lean against a wall

View of the Southwest Museum's historic bell tower

along noisy Figueroa Street or while you hang over the steering wheel of your car. That's why, on one especially warm spring day, I was happy to discover the tiny picnic area on the grounds of the Southwest Museum of the American Indian (one of three institutions under the umbrella of The Autry National Center).

This museum's entrance lies right at the border of Highland Park and Mount Washington, two vibrant urban neighborhoods known for their strong arts communities and historic architecture. On the northeast side of its large parking lot, hidden behind a thick row of cattails, four tables plus a mini set

of blood-orange bleachers overlook the hillsides of Montecito Heights and the museum's historic bell tower. On a clear day, the views extend as far as Pasadena and the San Gabriel Mountains. You can hear the muted rush of cars on the Arroyo Parkway, but you can see them only if you try really, really hard.

When my two small sons and I visited on a weekday afternoon, the sole other person we encountered was a local security guard, lunch bag in hand, who waved and winked at us conspiratorially before disappearing behind a fringe of cattails.

Note: Due to extensive renovations, public access to the museum itself is limited to one Saturday per month, but the grounds remain open to everyone on weekdays.

✌ essentials

▤ 234 Museum Drive, Los Angeles, CA 90065 📞 (323) 221-2164

🌐 theautry.org $ Free access to the grounds

🕐 Grounds: Monday–Friday, 9 a.m.–5 p.m., and one Saturday per month (check Web site for details)

🚌 Metro Rail Gold Line to Southwest Museum

Picnic tables overlook green hillsides and the Southwest Museum of the American Indian.

peaceful place 91

TASCHEN

Beverly Hills, West Los Angeles (MAP 3)

Category ✎ reading rooms ✪ ✪

*S*andwiched between the Cheesecake Factory and Christophe hair salon, this narrow walnut-veneered bookshop is an ideal place to escape from the bright sunshine and crowds that often dominate the Rodeo Drive shopping district. The collection is fun to browse—from stylish coffee-table books (such as *Valentino: A Grand Italian Epic* or *François Truffaut: The Complete Films*) to highbrow European travel guides. Don't miss the store's back section, where DVDs of movies tied to new releases often play, and a sitting area encourages visitors to page through Gutenberg Bible-size books that won't even fit in the average living room. Cap off a visit here with a trip up the nearly hidden stairs to "the cube," a stunning loft space with etched-glass walls and a rotating exhibit of

A flag welcomes book lovers outside Taschen.

photographs. A sleek, copper-covered couch invites more leisurely reading; the concealed staircase helps keep this area uncrowded and quiet.

⌣ essentials

✉	354 North Beverly Drive, Beverly Hills, CA 90210
☏	(310) 274-4300
🌐	taschen.com
$	Free browsing
🕐	Monday–Saturday, 10 a.m.–7 p.m.; Sunday, 11 a.m.–5 p.m.
🚌	Metro Bus Rapid 704 or 4

peaceful place 92

THEODORE PAYNE FOUNDATION
Sun Valley (MAP 7)

Category ⌣ outdoor habitats ✪ ✪ ✪

*C*ome to this nursery for its fine selection of golden poppies, lilacs, and other California native plants. Stay for a picnic surrounded by mature oaks and

Matilija poppies blanket the hills near the foundation.

fields of wildflowers. Theodore Payne was an England-born horticulturalist who championed the preservation of wildflowers and plants native to California; he is credited with making more than 400 species of native plants available to the public before his death in 1958. His foundation promotes and restores California landscapes and habitat and manages this hidden paradise beyond a bleak stretch of strip malls just north of the Bob Hope International Airport. The picnic area lies just off the parking lot in a secluded grove shaded by mature oaks. It's a natural playground for small children, who can run up and down hillocks and follow winding paths to nowhere, but

the tables and benches are spaced out so privacy seekers can easily stake out a quiet place of their own. After lunch, take the mile-long walk up Wildflower Hill, especially beautiful in the spring when Matilija poppies, blue lilacs, and other native flowers blanket the hills. Temperatures often reach triple digits in this part of town during the summer, so stick to winter and spring for the most enjoyable experience.

✍ essentials

⬛ 10459 Tuxford Street, Sun Valley, CA 91352 ⓒ (818) 768-1802

🌐 theodorepayne.org

$ Free picnic area; nursery selection prices range from $4 for seed packets to $30 for manzanita plants in five-gallon pots

🕐 July 1–October 13: Thursday–Saturday, 8:30 a.m.–4:30 p.m.; October 14–June 30: Tuesday–Saturday, 8:30 a.m.–4:30 p.m.

🚌 N/A

A secluded picnic grove

peaceful place 93

THORNHILL BROOME BEACH
Point Mugu State Park, Malibu (MAP 6)

Category ↙ outdoor habitats ✪ ✪

his is the Malibu beach to go to when you want to get away from Malibu. It's practically in Oxnard. Whether you park in either of the fee lots (see below) or for free along Pacific Coast Highway (PCH), it's an easy walk to the ocean. Rock formations frame Thornhill Broome to the south, and the bird-friendly Mugu Lagoon provides its northern boundary. Craggy hillsides that flank the eastern side of the PCH, which is invisible from the sand, make you feel even farther removed from civilization. A barbed-wire fence separates the beach from the Point Mugu Naval Base, but it's not as off-putting as it sounds. Birds that visit the nearby lagoon tend to congregate just over the fence from the beach, giving beachgoers an upfront view of the lagoon's thriving ecosystem. Regarding the fee lots, mentioned above, you have two parking areas from which to choose for Thornhill Broome Beach. I recommend that you continue driving past the main beach entrance and go on to the smaller, unmarked lot just before the naval base. It's quieter here, and you will likely have as many birds as people for your companions.

↙ essentials

🖃	9000 West Pacific Coast Highway, Malibu, CA 90265	✆	N/A
🌏	lamountains.com/parks.asp?parkid=156		
$	$11–$12 parking (or park for free along PCH)		
🕐	Daily, 7 a.m.–10 p.m.	🚌	N/A

peaceful place 94

THROOP MEMORIAL GARDEN
California Institute of Technology, Pasadena (MAP 8)

Category ✎ parks & gardens ✪ ✪

*A*shady pond and its huge family of turtles and billion-year-old boulders steal the show at this small campus park, named for Cal Tech's founder, Amos Throop. Walkways, bridges, and wide benches surround the pond and invite you to enjoy a mini escape into nature. The stones, scattered attractively throughout the landscape, were brought down from the nearby San Gabriel Mountains and represent two billion years in the geological history of California.

If school is in session, expect to share a bench or boulder with students or staffers also seeking a quiet place between class sessions. Still, if it's summer, you may just have the place to yourself (along with the turtles and an occasional frog).

Don't leave without walking around the kinetic Millikan fountain, just east of the library

Turtles sun themselves at Throop Memorial Garden.

(the tallest building on campus), and Dabney Garden, a secluded courtyard with olive trees, reading nooks, a wall fountain, and climbing roses. For a campus map, to be sure you don't miss these sites, stop by the admissions office on any weekday.

⌣ essentials

☰ 355 South Holliston Avenue, Pasadena, CA 91125 (admissions office)

✆ (626) 395-6341 🌐 caltech.edu $ Free

🕐 Park: Daily; Admissions office (for map): Monday–Friday, 8 a.m.–5 p.m.

🚌 Metro Bus Local Line 485; Pasadena ARTS Route 10

Resident turtles at Throop garden's pond

peaceful place 95

TREEPEOPLE CAMPUS

Coldwater Canyon Park, Studio City, Beverly Hills (MAP 7)

Category ✎ enchanting walks ✪ ✪ ✪

ithin the San Gabriel Mountain range, Coldwater Canyon Park has seemingly been around forever. A part of L.A.'s city-owned preserve and trail system, it's just around the bend from the busy intersection of Mulholland Drive and Coldwater Canyon. Just 10 minutes from downtown Beverly Hills, the park is so near, and yet so far, in terms of getting to the natural world.

The 2008 opening of the new headquarters of TreePeople, a nonprofit that helps urban communities plant and care for trees, added an exquisite retreat within this already-tranquil park. The TreePeople entrance actually sits at the border of Beverly Hills and Studio City, but much of the complex and its encompassing views lie on the San Fernando Valley side of the mountains. The campus includes a baby tree nursery, a solar-paneled environmental learning center, and clusters of benches creatively fashioned out of tree trunks. Close by, a small, shady amphitheater hosts live entertainment on summer nights, but serves as a hideaway for quiet contemplation any other time. Also, school groups are a frequent sight during the week, but it's still easy to find a quiet space somewhere on the property. (Maps of the campus are available at the entrance.)

For sure, a visit isn't complete without taking the easy walk up to Torrey Pines Lookout, a clearing with several of those magnificent eponymous trees. Here you'll also find a cluster of picnic tables with captivating views of the entire valley to the north. Dogs are welcome, and if you happen into the yurt village that serves as TreePeople's offices, staffers might just invite you to help them plant seedlings.

Note: A small parking lot is open to the public and includes several reserved spaces for carpoolers.

⌣ essentials

☰ 12601 Mulholland Drive, Beverly Hills, CA 90210

✆ (818) 753-4600

🌍 treepeople.org

$ Free

🕐 Daily, 6:30 a.m.–sunset

🚌 N/A

peaceful place 96

TURRELL SKYSPACE

Pomona College, San Gabriel Valley (MAP 8)

Category ⌣ museums & galleries ✪ ✪

*E*veryone loves a good sunset, and this Pomona College architectural installation may be the best place to watch it east of the 405 freeway. Created by artist (and Pomona College graduate) James Turrell, it is one of a handful of public installations around the world designed to heighten awareness of light and sky. From a distance, it looks like a small open-air courtyard with marble benches and a shallow reflecting pool in the center. A metal canopy floats above the space and provides a frame to the sky. As the sun sets, LED lights bathe the canopy in an array of changing colors. The entire sunset program takes about an hour, starting off slowly with muted shades of gray and lavender and building to striking swaths of turquoise, blue, and burnt umber as the sky fades to night. It is a Sunday and

Fans gather for a unique sunset experience.

Monday evening ritual that attracts an eclectic mix of fans, from professors and packs of undergrads to families with small children. Instead of triggering feelings of remoteness or introspection, the Skyspace seems to create a subtle camaraderie among its guests, caused perhaps by the shared witnessing of such an unusually beautiful sight.

⌣ essentials

⊟ Draper Courtyard, Sixth Street and College Way, Pomona College Museum of Art, 333 North College Way, Claremont, CA 91711

☏ (909) 621-8283 ⊕ pomona.edu/museum $ Free

🕐 Saturday—Monday; lighting programs begin about 25 minutes before sunset and 100 minutes before sunrise

🚌 Foothill Transit Line 189; Amtrak and Metrolink San Bernardino lines to Claremont

Open-air courtyard at Turrell Skyspace

peaceful place 97

UCLA HANNAH CARTER JAPANESE GARDEN

Bel-Air, West Los Angeles (MAP 3)

Category ⌣ parks & gardens ✪ ✪ ✪

*L*os Angeles has plenty of fabulous gardens, but this hillside Bel-Air haven is arguably one of the best. That is in part because you'll share it with, at most, a handful of other admirers. Two landscape designers from Japan created the gar-

dens, modeling them in the Kyoto style of centuries ago. In 1965, Edward W. Carter, the chairman of the regents of the University of California, donated the site, named after his wife, Hannah, to UCLA.

In the vicinity of Hotel Bel-Air (closed for major renovations until mid-2011), this peaceful destination lies only a mile from UCLA's campus. But spend an hour here (and, alas, that's all each person is allowed), and you will feel like engaging in a more graceful world. Japanese maples, black bamboo, camellias, and azaleas blanket the hills, and serpentine paths and steep stairs lead you past symbolic rocks,

A Japanese teahouse at UCLA Hannah Carter Garden

benches, a traditional teahouse, and tumbling waterfalls. If you time a visit for midsummer, the lotus beds should be in glorious pink bloom, but any time of year has its merits here. The only downside? Once you have covered the suggested counterclockwise loop, it's time to go and let the next small group of visitors enjoy it.

⌣ essentials

⊟ 10619 Bellagio Road, Bel-Air, CA 90077 📞 (310) 794-0320

🌍 japanesegarden.ucla.edu $ Free

🕐 Tuesday, Wednesday, and Friday, 10 a.m.–3 p.m. (reservations required)

🚌 Metro Bus Local Line 2

Lotus flower in bloom

peaceful place 98

UNION STATION LOBBY AND COURTYARDS
Downtown Los Angeles (MAP 1)

Category ⌣ historic sites ✪ ✪

here are few better places to wait for a train than on the gently worn brown-leather chairs in Union Station's cavernous lobby. No matter how crowded the place gets with bus, train, and subway passengers, an empty seat can always be found with a prime view of the soaring ceilings and grand Art Deco architecture. Sometimes, however, the strong scent of onion bagels from the nearby deli, plus the constant parade of modern rolling suitcases, gets to be too much.

MTA's courtyard has tiled fountains, tables, and a quiet vibe.

That's when it's time to seek out the Metropolitan Transit Authority's large open courtyard on the east side of the building. Plenty of benches and tables are shaded by umbrellas, all anchored by a beautiful tiled fountain at the center. The courtyard attracts a mix of travelers, MTA employees, and random downtown office workers, so it's as interesting for people-watching as the lobby proves to be. If you're looking for an idle way to pass the time, observe the faces of the people who enter the courtyard from Union Station. You can tell it's their first visit by the pleasantly surprised looks on their faces.

⌣ essentials

⌸ 700–800 North Alameda Street, Los Angeles, CA 90012

📞 (213) 683-6875 🌐 american-rails.com/los-angeles-union-station.html

$ Free 🕐 Lobby and courtyard open daily, 24 hours

🚌 Metro Rail Red or Yellow Line to Union Station; DASH Route B

Union Station's leather chairs beckon weary travelers.

peaceful place 99

VARNISH

Downtown Los Angeles (MAP 1)

Category ↝ quiet tables ✪ ✪

he entrance to this tiny bar is an unmarked door in the back room of a roast-beef-dip palace called Cole's. If that doesn't sell you on its character, then the deep leather booths and classic cocktail menu surely will. Even when all the booths are filled and the padded bar is two-deep in tipplers, it's an intimate place for long, gin-fueled conversations with a close pal. The fact that each drink order sometimes takes 15 minutes to fill should be viewed as a sign that the suited-up bartenders take their mixology very

Varnish bar lies in the back room of a popular sandwich place.

seriously. The short cocktail menu gives tribute to classics such as Remember the Maine (rye, vermouth, cherry liqueur, and absinthe), the Stinger (brandy and crème de menthe), and hot buttered rum. A fine dirty martini and selection of liqueurs are also available. Sometimes soft guitar or piano music is playing, and, if you ask nicely, they may let you order a French dip from Cole's and have it delivered to your table. Cheers.

⌣ essentials

⊟ 118 East Sixth Street, Los Angeles, CA 90014

✆ (213) 622-9999

🌐 thevarnishbar.com

$ Cocktails start at $11; French dips, $6–$10

🕐 Monday–Saturday, 6 p.m.–2 a.m.

🚊 Metro Rail Red Line to Seventh Street/Metro Center; DASH Route D

peaceful place 100

VASQUEZ ROCKS

Agua Dulce Springs (FARTHER AFIELD: MAP 9)

Category ⌣: day trips & overnights ✪ ✪

With its giant tilted rock formations and *Planet of the Apes* landscape, this 900-acre park makes a great destination for anyone who wants to experience Los Angeles beyond Hollywood Boulevard and the beaches. Tucked into the northernmost corner of Los Angeles County near Santa Clarita, Vasquez offers one of the coolest high-desert experiences one can have outside of Death Valley.

When you arrive at Vasquez Rocks, you will follow an unpaved road to the main parking lot, where one of the first things you will note is the intimidating sight of

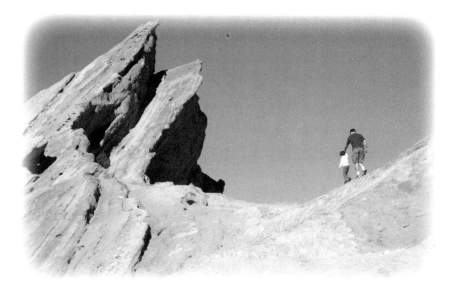

Climbing Vasquez Rocks

people walking up the 150-foot-tall rocks. Don't be put off. For one thing, the park's vastness keeps it from feeling crowded. For another, the gradual inclines make for easy walking, and at the top you will be rewarded with sweeping views of the park and the surrounding Antelope Valley.

What I like best about the place is that it's made for roaming. Pick a path or the direction toward a particular rock formation, and start walking. Soon you'll be away from all signs of civilization and surrounded by sagebrush, juniper trees, and rock slabs formed by millions of years of earthquakes and erosion. From time to time, you'll come upon a picnic table, where you can sip your cooling beverage and enjoy the snack you thought to pack. While I find it easy to feel pleasantly isolated here, Vasquez Rocks does attract enthusiastic fans. Hundreds of films and TV shows have been shot here, including *Star Trek, Bonanza, 24,* and *Buffy the Vampire Slayer.* Many visitors come to see the exact spot where William Shatner faced the Gorn, or the very rock on which Little Joe Cartwright left his rifle.

Tip: Temperatures can be extreme (as much as a 20-degree variance between Vasquez Rocks and downtown L.A.), so plan your dress, water, and snacks accordingly.

✎ essentials

✉	10700 West Escondido Canyon Road, Agua Dulce, CA 91390
✆	(661) 268-0840
⊕	lacountyparks.org
$	Free
⏱	Daily, 9 a.m.–5 p.m.
🚌	N/A

peaceful place 101

VENICE CANALS

Venice (MAP 4)

Category ↝ enchanting walks ✪ ✪

*T*he charming walkways and bridges of Venice hark back to a time when cars didn't rule Los Angeles. Modeled after Italy's famous canals, they were carved out of salt marshes in the early 1900s as part of developer Abbott Kinney's grand plans for a seaside resort, the Venice of America. Remarkably, the homes that line the canals retain an old-fashioned quaintness that you'd be hard-pressed to find anywhere else in today's Los Angeles.

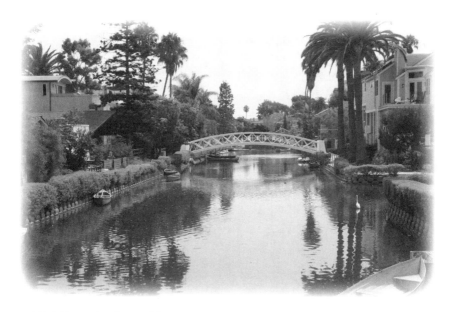

The bridges and walkways of Venice are open to everyone.

To begin a terrific stroll, you may access the public walkways and bridges south of Venice Boulevard between Eastern Canal Court and Grand Canal Court. This outing makes a great way to combine exercise with a bit of architectural window peeping (from a polite distance). Every home—whether it's Craftsman style, a fixer-upper cottage, or a multistoried mansion—is fascinating. Some have kayaks bobbing next to small docks; at others, outsize fig trees and decks with exercise bikes overlook the water. Along the canal, you might see turtles and waterfowl such as ducks and cranes.

Perhaps the most pleasant surprise I've found on my walks here is the people. Almost everyone is quick with a smile or friendly nod. I guess it comes with living in such an idyllic environment. Twilight is a beautiful time to visit the canals, though weekday mornings offer the easiest parking options in this neighborhood.

essentials

Venice Boulevard to 28th Avenue and Eastern Canal Court to Grand Canal Court, Venice, CA 90291

N/A

N/A

Free

Anytime

Metro Bus Local Lines 33 or 333

peaceful place 102

WATERFRONT RED CAR LINE

San Pedro (MAP 5)

Category ↙ urban surprises ✪ ✪

hough sometimes hard to believe these days, cars and freeways did not always dominate Southern California. A network of electric street trolleys known as Red Cars used to be the main way to get around, from Santa Monica all the way to the San Gabriel Valley and beyond. (If you saw the 2008 film *Changeling*, based on a true story and directed by Clint Eastwood, you likely recall several vivid re-creations of 1920s Los Angeles, with leading actress Angelina Jolie portraying the real Christine Collins boarding and riding Red Cars.)

Well, the last Red Car retired in 1961, but you can still experience this very relaxing form of transportation in the seaport town of San Pedro, on the southeastern edge of the Palos Verdes Peninsula. Two trolleys, replicas of the original Red Cars, run up and down San Pedro's waterfront throughout the year. Stops include the dandy little Los Angeles Maritime Museum, Ports O' Call Village (home to seafood stands and storefronts that attract big crowds on summer weekends), and a cruise ship terminal where *Love Boat*–like ships depart regularly for Mexico, Alaska, and Hawaii.

If you time it right, you can ride the trolley from one end to the other and catch the twice-hourly dancing fountain show near the World Cruise Center. I have witnessed many passengers who choose not to get off the car at all, preferring to ride the immaculate trolleys up and back a few times with enchanted looks on their faces. At night, the port town takes on a noirish vibe (perhaps in the spirit of Beat writer and one-time San Pedro resident Charles Bukowski), and the Vincent Thomas Bridge provides a beautiful blue-lit backdrop.

ᴗ᷉ essentials

⊟ North Harbor Boulevard at Swinford Street, San Pedro, CA 90731

☏ (310) 732-3473

🌐 railwaypreservation.com and portoflosangeles.org/recreation/waterfront_rcl.asp

$ $1 for age 7 and up for unlimited rides all day; fare collected on the trolley; exact change required

🕐 Friday–Sunday, noon–9 p.m. (operates other days when cruise ships are in port)

🚌 Metro Bus Express Line 445; LA DOT Commuter Express Bus 142

peaceful place 103

WATSU® MASSAGE

Various locations (not shown on accompanying maps)

Category ↝ shops & services ✪ ✪ ✪

*W*atsu® is a series of gentle movements and stretches carried out in a pool of water heated to body temperature. It is all about letting go—of pressures, daily routines, inhibitions—and allowing yourself to be guided and cradled by a trained instructor for one blissful escapist hour.

Harold Dull, a massage therapist in Northern California, developed the practice in 1980 (and registered it as a trademarked service) while combining two soothing activities: the stretches and moves of his Zen Shiatsu classes, plus floating in water. As a treatment, Watsu® is showing up on an increasing number of spa menus across the United States.

In Los Angeles, the best way to experience it is through Davida Taurek, a yoga and dance instructor who offers Watsu® in pools in the metro

Davida Taurek prepares for a Watsu® session.

area several times a year. Taurek incorporates elements of yoga and dance into her Watsu® treatments and is as gentle and relaxing as you could ask for. I approached my session with Taurek expecting something like a basic massage that takes place underwater (with your head above the surface, of course). Instead, I literally floated in an hour of womblike meditation that forced me to slow down and listen to the soothing swish of water and rhythm of my heartbeat. I left feeling nurtured and calm, with a total balance of mind that no typical massage ever managed to accomplish.

↙ essentials

▤	Malibu, Brentwood, and Culver City (call or e-mail for specific locations)
✆	(415) 455-8981; (310) 994-5405; or e-mail davida@davidadance.com
🌐	davidadance.com and watsu.com
$	Watsu® rates generally start at $135 per hour
🕓	Per appointment
🚗	Varies according to location

peaceful place 104

WATTLES GARDEN PARK
Hollywood (MAP 2)

Category ↝ parks & gardens ✪ ✪ ✪

*T*his city-owned park is sort of like the shy older sibling of uber-popular Runyon Canyon Park, which is right next door. If you're into power walks and celebrity sightings, Runyon Canyon is one of the best places L.A. has to offer: Its strenuous 3-mile loop is one of the city's top outdoor cardio workouts. But when you're in the mood for a quiet stroll or a picnic on the lawn of a faded Hollywood estate, head a few blocks over to Wattles Garden Park, where you'll find equally good views, rows of giant palm trees, and the eerie remains of a Japanese teahouse and garden. The property once belonged to Nebraska banker Gurdon Wattles, who spent winters in the Mission Revival mansion. Designed by Myron Hunt and Elmer Gray (the architects behind the Ambassador Hotel and other Southern California

Freestanding columns line Wattles Garden Park.

landmarks), the mansion is open only for special events. It can be viewed, however, through a chain-link fence that separates it from the street and public park.

Enter the park through a large gate on Curson Avenue, north of the mansion. A neighborhood secret favored by dog walkers and occasional sunbathers, the place is mostly deserted, even on weekends. If the quiet and quirks (such as random graffiti and freestanding stucco columns that support nothing) get to you after a while, follow the cement steps up through the pagoda and hook up with a dirt trail that will eventually take you over to the trails and people-watching opportunities of Runyon Canyon.

⌣ essentials

▣	1824 North Curson Avenue, Los Angeles, CA 90046
◐	N/A
◈	laparks.org/dos/parks/facility/wattlesgardenpk.htm
$	Free
◔	Daily, sunrise–sunset
⛟	Metro Bus Local Line 217

peaceful place 105

WATTS TOWERS AND WATTS TOWERS ARTS CENTER
Watts, South Los Angeles (MAP 1)

Category ↙: museums & galleries ✪ ✪

A close-up view of Watts Towers

*T*he neighborhood of stucco bungalows that surrounds Watts Towers was the site of fierce race riots in 1962 and 1992, yet a visit to this strangely beautiful monument leaves you feeling more hopeful than turbulent. Built without machines by Italian immigrant Simon Rodia, who had worked in quarries and other types of construction, the colorful, nearly 100-foot-high towers took more than 30 years to complete. (Rodia called his creation *Nuestro Pueblo.*) While the towers don't quite belong with other famous L.A. icons, such as the Hollywood sign or Santa Monica's beaches, they are a must-stop on any complete tour of Southern California.

Many visitors pick up their tickets for a guided tour of the towers at the nearby arts center but stay only to watch the documentary that accompanies every

tour. However, the arts center itself also deserves a long and thoughtful visit. Outside, a mural honoring local African American arts leader Cecil Ferguson covers one wall, while another piece mimics Rodia's mishmash of tiles, glass, mirrors, and miscellaneous fragments. Inside, the light-filled gallery exhibits rotating works by local artists whose renditions often embody in some way, or were inspired by, the towers outside. A grand piano sits in one corner, and staff members are happy to tell you about the current exhibit and the center's long history as a neighborhood youth hub for art workshops, piano lessons, and drum circles.

⌣ essentials

📧 1761 East 107th Street, Los Angeles, CA 90002 📞 (213) 847-4646

🌐 wattstowers.us

$ Free admission to arts center, though donations are welcome; guided tours are $7 for adults and $3 for seniors and children ages 13–17

🕐 Wednesday–Saturday, 10 a.m.–4 p.m.; Sunday, noon–4 p.m.

🚌 Metro Rail Blue Line to 103rd Street

Watts Towers Art Center is a peaceful community hub.

peaceful place 106

WAYFARERS CHAPEL
Palos Verdes (MAP 5)

Category ⌣ scenic vistas ✪ ✪

*A*rchitecture converges with nature in this stunning glass chapel designed by Lloyd Wright (son of Frank). Flanked by redwoods, giant pines, and panoramic ocean views, it is a sanctuary that welcomes anyone to sit in its pews and pray, reflect, or simply admire its unique design. If the chapel is occupied, head outside and sit for a spell on a bench overlooking the Pacific. Then tour around the landscaped gardens and let your eyes and nose bask in the year-round roses, azaleas, and lilies. Stop by the reflecting pool and forget completely that you are only minutes from the 405 freeway. Assembly-line weddings, held every two hours, take over the place on Saturdays, and worship services and baptisms dominate Sundays, so stick to weekdays to avoid crowds and parking hassles.

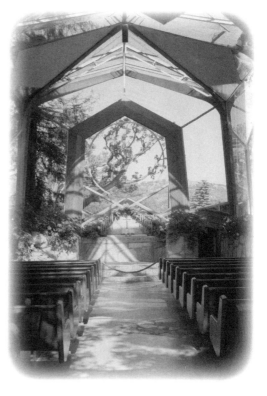

Hushed interior of Wayfarers Chapel

Note: The small visitor center offers maps and more information about the chapel and its sponsor, the Swedenborgian Church.

⌣ essentials

⌷ 5755 Palos Verdes Drive South, Rancho Palos Verdes, CA 90275

☎ (310) 377-1650

🌐 wayfarerschapel.org

$ Free; $1 donation for a self-guided map

🕐 Chapel: Daily, 8 a.m.–5 p.m.; Visitor center: Daily, 10 a.m.–5 p.m.

🚌 N/A

peaceful place 107

WILL GEER THEATRICUM BOTANICUM

Topanga Canyon (MAP 6)

Category ⌣ parks & gardens ✪ ✪

*T*he spirit of Grandpa Walton (played by actor Will Geer) reigns over the forested grounds of this outdoor amphitheater, created by Geer as a haven for actors blacklisted as

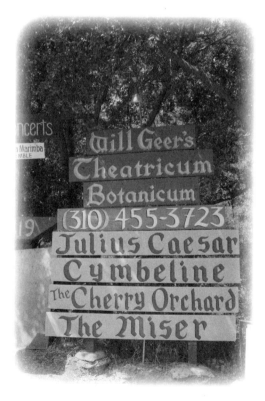

"Communists" during the 1950s Red Scare, the political witch hunt fueled most notoriously by Wisconsin Senator Joseph McCarthy. Now, in happier times, the botanicum is run by Geer's daughter Ellen and is known for its Shakespeare performances and year-round roster of acting and theater workshops. On a starry summer evening, the picnic area may be the best place in the city to enjoy a pretheater wine and cheese ritual. Pick a table, log, or porch swing and relax amid the sycamore, oak, and pine trees scattered throughout the picnic area. At the center is a formidable bust of Will Geer and a garden that, at the

Entrance to Theatricum Botanicum

actor's behest, showcases many of the herbs and flowers (such as columbine or boxwood) mentioned in the Bard's works. A daytime visit is just as pleasant; kids can expend some energy on the paths and bridges before a Sunday concert, and grown-ups can revel in the natural, fresh-air setting. No ticket is required to enter the picnic area, though expect it to be busy in the hour before curtain time. The grounds are open to the public daily, but it's a good idea to call first if you're not planning your visit around a performance. The picnic area is sometimes used for workshops and other events.

⌣ essentials

☰ 1419 North Topanga Canyon Boulevard, Topanga Canyon, CA 90290 🕐 (310) 455-2322

🌐 theatricum.com $ Free picnic area; performance tickets cost $8–$28

🕐 Picnic area open daily; repertory season runs May–September

🚂 Amtrak or Metrolink trains to Ventura

A bust of Will Geer in the Shakespeare garden

peaceful place 108

WILLOW SPA

Santa Monica (MAP 4)

Category ✒ shops & services ✪ ✪ ✪

*T*he enzyme bath at this tranquil site is not your typical aromatherapy-and-candles spa treatment. Think of it as a 20-minute rest on the world's most comfortable couch, with benefits that last for days. Based on a deep-heating treatment developed for Japanese athletes in the 1964 Olympics, it is essentially a soak in a large tub filled with a naturally heated combination of wood shavings, rice bran, and fruit-and-vegetable enzymes. An attendant buries you in this "sawdust" up to your neck, wipes your brow with a cool cloth, and offers water at regular intervals. Surrounded by a red curtain, cedar walls, and soft music, you might as well be in another country for all you will be aware of what's happening outside the room. After the bath, the detoxification process continues with a 30-minute Thai massage. (The

Willow Spa's outdoor lounge

whole experience left me feeling like I had just finished a 5-mile run: I slept like a baby and had a healthy, almost ravenous, appetite for days.)

After the 75-minute treatment, you may linger as long as you like in Willow's outside waiting areas where hot tea, footrests, soft pillows, and trickling fountains extend the Zen experience. For those wary of shelling out $110 for a spa treatment, try the peaceful hatha yoga classes held on Saturday mornings; you'll still enjoy the tranquil ambience of this delightfully down-to-earth spa.

↩ essentials

▤ 3127 Santa Monica Boulevard, Santa Monica, CA 90404 (310) 453-9004

🌐 willowspa.com

$ Japanese enzyme bath: $110; the first yoga session is free, then $16 per class

🕐 Monday, Tuesday, and Friday, noon–7 p.m.; Thursday, 4 p.m.–9 p.m.;
Saturday–Sunday, 10 a.m.–7 p.m.

🚌 Metro Bus Rapid Line 704; Big Blue Bus Lines 1, 10, or 11

Enjoy tea and a foot soak in the waiting area.

peaceful place 109

WRIGLEY GARDENS AT TOURNAMENT HOUSE
Pasadena (MAP 8)
Category ✍ parks & gardens ✪ ✪ ✪

*F*ans of the Tournament of Roses parade needn't wait until January to get their annual flower fix. The small rose garden at the event's Pasadena headquarters remains open year-round. Come here to revel in dozens of varieties of roses, including the rose developed especially for the floats participating in the annual Tournament of Roses parade. It's a beautiful place to bring flower lovers or folks visiting from a cold climate during winter. Even better to come here alone when you need a personal pick-me-up.

Meander among the meticulous rows of roses, camellias, and annuals, all of which are identified with small signs. Or just relax on one of the benches and inhale the fragrant scent that permeates the property. I have never encountered anyone else here, but it's probably best

Under the trellis at Wrigley Gardens

to avoid the grounds in late December, when parade preparations reach a frenzy, and out-of-town Bowl fans and tourists take over Pasadena. Visit on a Thursday afternoon, and you can include on your agenda a tour of Tournament House (once the home of chewing-gum magnate William Wrigley Jr.).

⌣ essentials

▤ 391 South Orange Grove Boulevard, Pasadena, CA 91184

☏ (626) 449-4100

⊕ tournamentofroses.org (click on "About Us" and look under "Tournament House")

$ Free

🕐 Daily, sunrise—sunset

🚌 Pasadena ARTS Route 10

peaceful place 110

ZONA ROSA CAFFE
Pasadena (MAP 8)

Category ↙: quiet tables ✪ ✪

*A*t first glance, this tiny storefront looks like just another place to grab a quick cup of joe before a show at the Pasadena Playhouse or after browsing the antiques shops on nearby Green Street. Follow the narrow staircase upstairs, however, and you'll find a sun-dappled lounge with all the fixings for a leisurely couple of hours curled up with a laptop or good novel.

Day of the Dead banners hover like laundered handkerchiefs above three comfortable sofas and chairs, themselves draped with serapes. Paintings by local artists decorate the purple and white walls, and a community chessboard hints that lingering is encouraged. Soft Latin music adds to the escapist vibe. The coffee is strong, and the tea and pastry selection wide, but those in the know opt for the Mexican hot

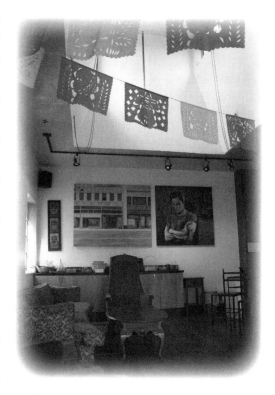

Upstairs lounge at Zona Rosa

chocolate, a house specialty. Evenings tend to draw theatergoers and lots of students (Cal Tech is a mile away), so visit during the day for the quietest experience.

⌣ essentials

⊟ 15 South El Molino Avenue, Pasadena, CA 91101

☏ (626) 793-2334

🌐 zonarosacaffe.com

$ Mexican hot chocolate and other specialty drinks start at $3

🕐 Monday, 7:30 a.m.–9 p.m.; Tuesday–Thursday, 7:30 a.m.–11 p.m.; Friday–Saturday, 7:30 a.m.–midnight; Sunday, 9 a.m.–10 p.m.

🚌 Metro Rail Gold Line to Lake Avenue; Pasadena ARTS Route 10 or 20

about the author

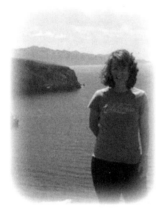

Laura Randall

A resident of Los Angeles since 1999, Laura Randall writes about travel and other topics for publications that include the *Los Angeles Times, The Washington Post, Sunset* magazine, and *The Christian Science Monitor.* She served as a writer and editor for the 2009 and 2010 editions of Zagat's *Disneyland Insider's Guide*, and has been a contributor to annual editions of *Fodor's Los Angeles* since 2004. She also is the author of *60 Hikes within 60 Miles of Los Angeles*, published by Menasha Ridge Press.